TAKE
BETTER PICTURES

TAKE
BETTER PICTURES

Published by Time-Life Books in association with Kodak

TAKE BETTER PICTURES

Created and designed by Mitchell Beazley International
in association with Kodak and TIME-LIFE BOOKS.

Editor-in-Chief
Jack Tresidder

Series Editor
John Roberts

Art Editor
Mel Petersen

Editors
Ian Chilvers
Lucy Lidell
Joss Pearson
Richard Platt

Designers
Robert Lamb
Lisa Tai

Picture Researchers
Brigitte Arora
Nicky Hughes

Editorial Assistant
Margaret Little

Production
Peter Phillips
Jean Rigby

Consulting Photographer
Michael Freeman

Coordinating Editors for Kodak
Kenneth Lassiter
Kenneth Oberg
Jacalyn Salitan

Consulting Editor for Time-Life Books
Thomas Dickey

The KODAK Library of Creative Photography
© Kodak Limited All rights reserved

Take Better Pictures
© Kodak Limited, Mitchell Beazley Publishers,
Salvat Editores, S.A., 1983

Library of Congress catalog card number 82-629-73
ISBN 0-86706-200-2
LSB 73 20L 01
ISBN 0-86706-202-9 (retail)

Printed by Printer Industria Gráfica S.A.
Provenza, 388, Barcelona
Depósito legal B. 23384-1984
Printed in Spain

Contents

THE KEY TO PHOTOGRAPHY

The best photographs are simple. They convey a message directly and vividly – whether the joy of a family reunion or the splendour of a canyon lit by the evening sky. This same simplicity often applies to the way they are taken. Creative photographers develop the ability to take interesting pictures by the most straightforward means. Modern cameras and films, efficient and easy to use, have greatly reduced difficulties in assessing exposure and other such technical problems – freeing the photographer's eye and imagination. The aim of this book is to show that anyone, from the novice to experienced – and often frustrated – amateur, can master the simple techniques and clear creative principles that will transform their photography.

The pictures on the following nine pages include striking images that any photographer would be proud to take. But in spite of their high quality, none involved difficult techniques, and indeed several were taken by amateurs. The key to the success of these pictures is that each concentrates on a single uncomplicated idea.

The pure white facade of a colonial weatherboard house demonstrates that simple images are often the strongest. The photographer crouched low and tilted his camera to exclude every distraction and reduce the scene to two elements – blue sky and gleaming house.

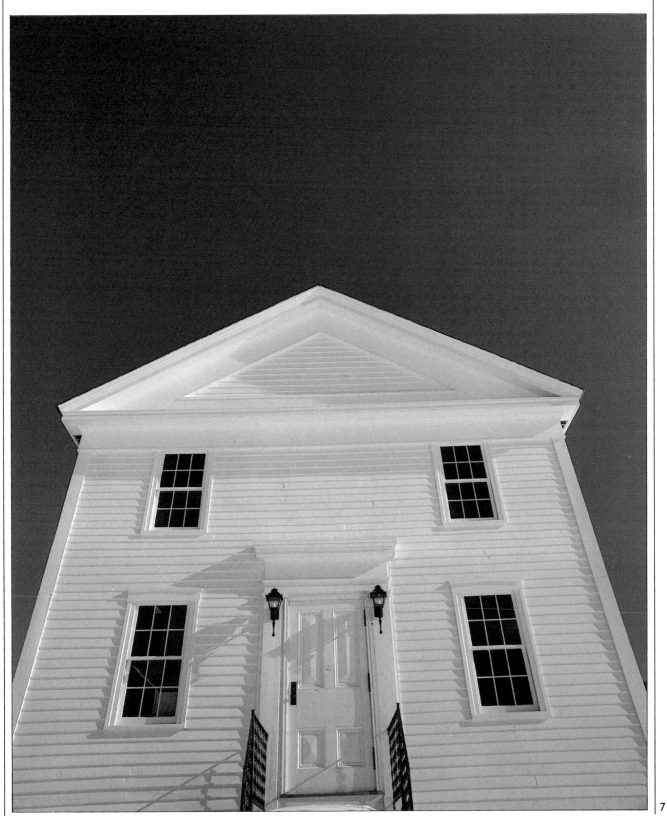

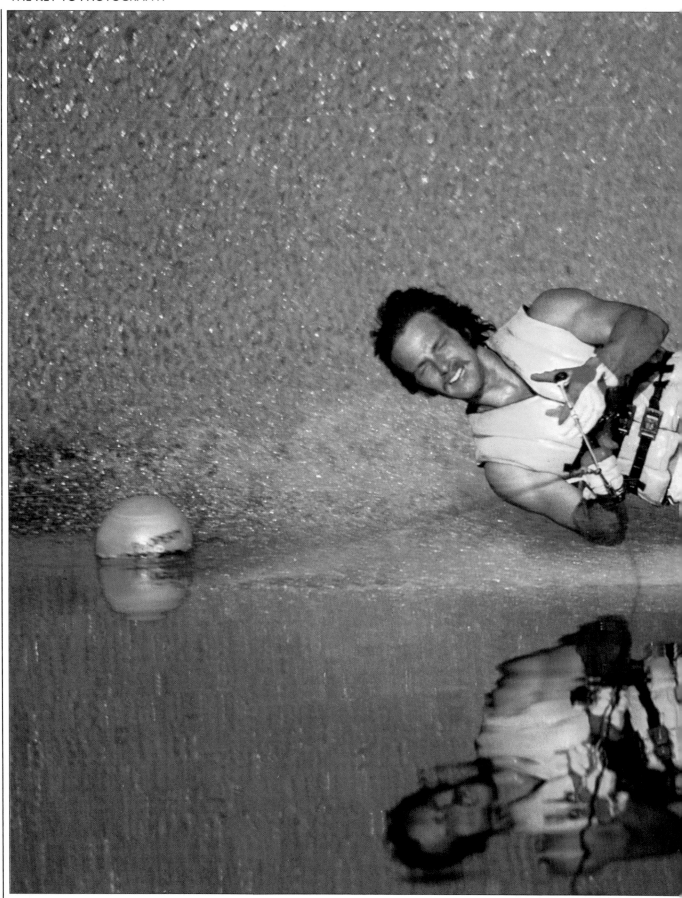

The clean drama of a near-horizontal water-skier against a wall of spray and an unexpectedly calm reflection combine in a remarkable action shot. This picture was taken from the rear of the towing boat, using a telephoto lens and a fast shutter speed. The impact of the image is heightened by its basic clarity and isolation from any visual clutter – the skier almost filling the width of the frame and snapped just as he banks over to round the buoy, leaving clear water between him and the speeding boat.

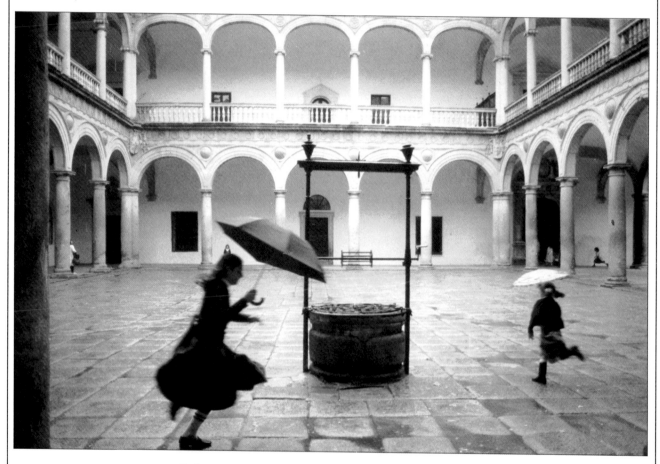

Rainy weather, *often thought unsuitable for photography, creates some of the most interesting photographic opportunities. Amateur Luis Huesco took advantage of it when he was on a tour of a Spanish museum. Through a half-open door, he noticed the chance presented by two children playing alone in a drenched courtyard. In spite of their rushing figures, the scene seems charged with an eerie stillness, an effect created by the weather's grey mood in the symmetrical setting.*

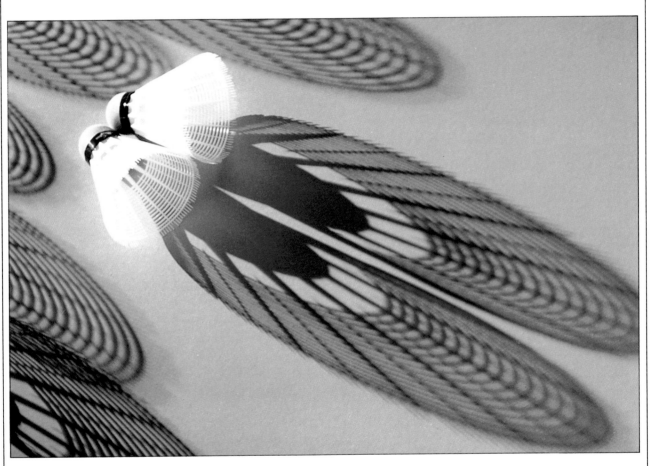

The inspired pattern of this unusual image came from the photographer's simple realization that a plaything such as a badminton shuttlecock can cast fascinating shadows when placed in front of a strong light source. By mating a pair of shuttlecocks in the light of a slide projector, the delicate ribbed wings of a shadow-insect were created.

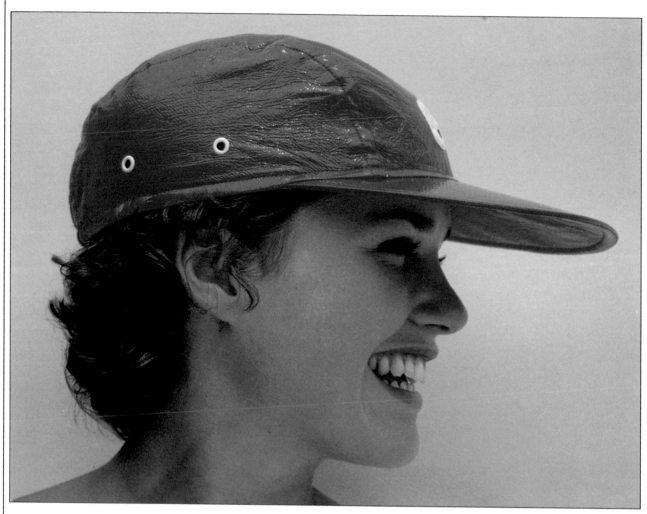

The sparkle of a smile and the bright red of a sun hat in the picture above lend the simplest of portraits an infectious gaiety. The photographer moved in close to frame the girl against the plain white wall and intensify the impact of the peaked cap above her glowing face.

The yellow rain hat pulled over the child's face makes a telling portrait that needed only an open response to the sudden opportunity. Many photographers would have waited, or asked the boy to lift the hat up again for a clear view, missing the drama of the invisible face.

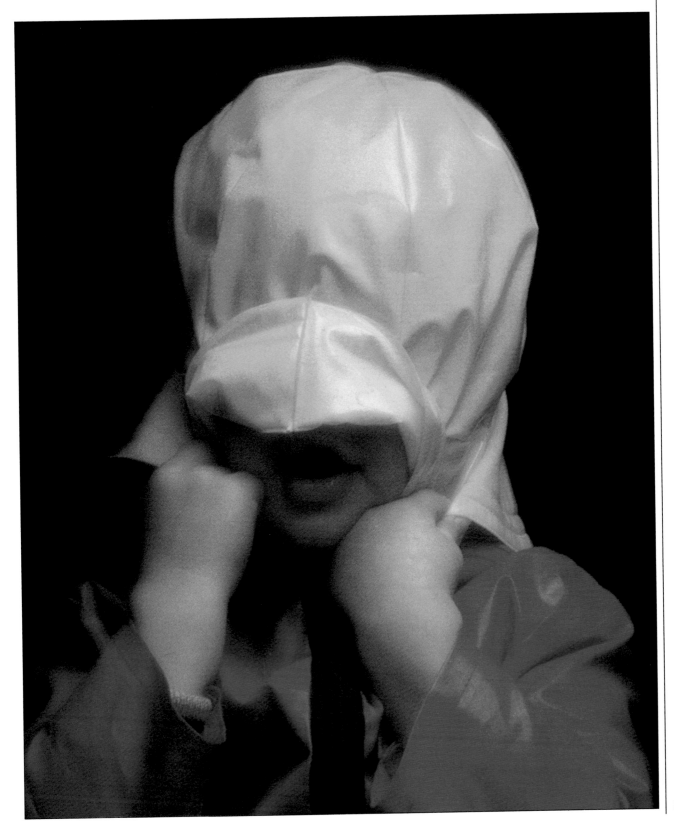

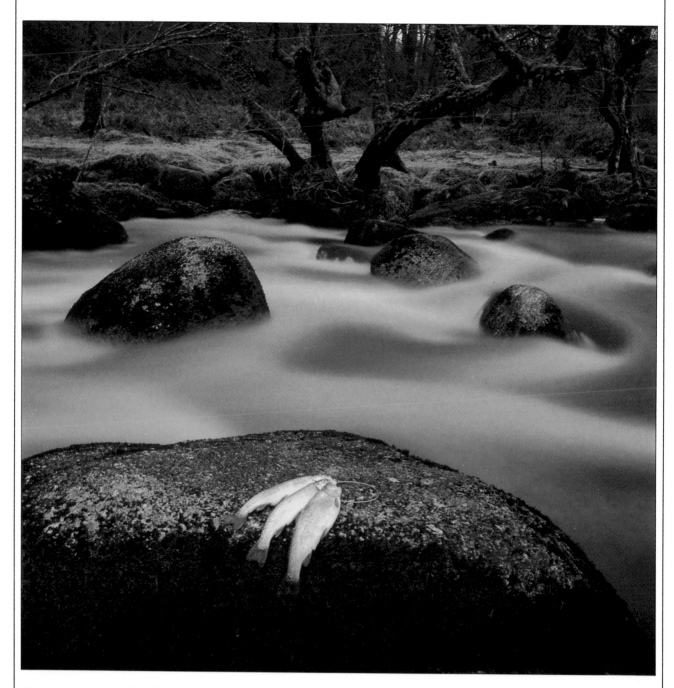

Blurred water – *achieved by a slow shutter speed* – *in this sombre landscape has smoothed out the one active element of the scene and turned the picture into a hauntingly beautiful still-life. The strange effect was surprisingly easy to create, needing no more than a time exposure of a few seconds.*

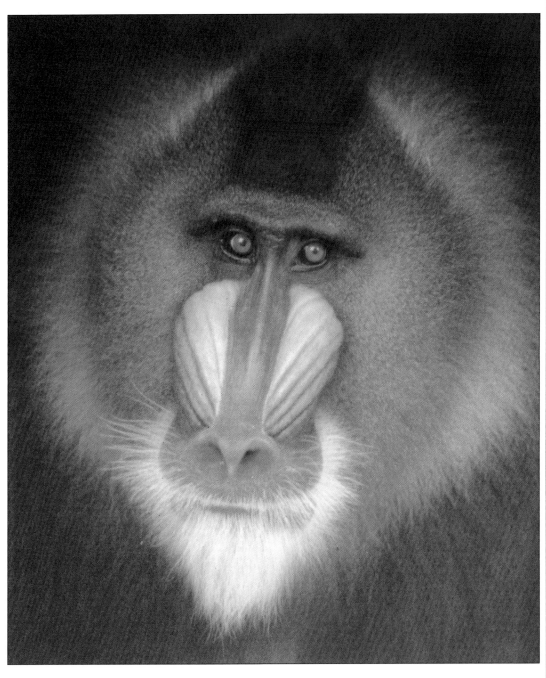

A majestic baboon, *isolated by a telephoto lens, displays the soft colours and strongly defined patterns of his facial markings. Like many good animal shots, this is not an exotic wildlife picture: the photographer spotted the baboon in the shady doorway of its zoo den, and closed in.*

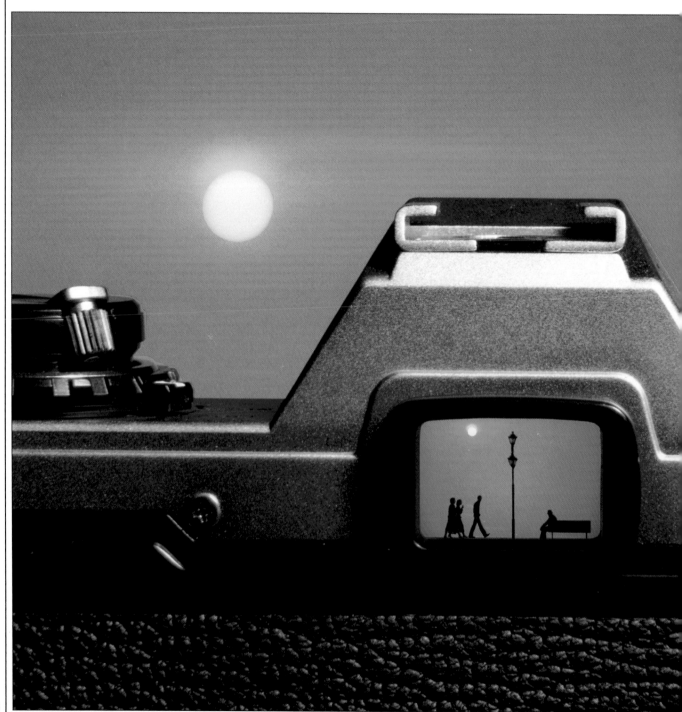

YOU, THE PHOTOGRAPHER

Good photographs come from developing an eye for a picture – not from using banks of powerful studio lights, whirring motor-drives or two-foot-long telephoto lenses. Success requires no more than the ability to make the essential creative leap from what you see to what will work as a photographic image. The secret of doing this is to train the eye to see images that will give pleasure when they are taken out of the complex, confused and constantly shifting world and made into photographs isolated by their frames.

Experienced photographers become adept at identifying interesting images largely because they spend a great deal of time looking through the viewfinders of their cameras. Anyone can learn to see pictures in the same way. Look through the viewfinder frequently, even when you do not intend to take a picture. Concentrate on what you can actually see in the frame and how the shapes or colours there work together. You can practise this way of seeing even when you do not have a camera with you – remember the old artist's trick of holding the hands up as a frame? This creative and imaginative process is at the heart of photography, and the pictures on the following pages emphasize how much effective images depend on vision itself.

The viewfinder is your photographic link with the world in front of the camera. Here, the edges of its frame isolate four silhouetted figures from the bustle of a city park. The picture is compelling because the photographer used the camera's special eye to select the right image at the right moment.

Seeing pictures

Distant details, such as the woman walking her dog, may attract the eye, but are not clearly visible. However, with a telephoto lens, the camera can close in on such images.

To begin seeing as the camera sees, you need to recognize its basic powers – and limitations. First, consider the similarities between the camera and the eye. Both use a lens to focus an image on a surface that is sensitive to light. And a camera has ways of controlling the intensity of the incoming light, much as the pupil of the eye does. But, while these parallels are interesting, the differences are actually more relevant when you try to take pictures. In particular, the eye has vastly greater flexibility, working automatically in a way that the most advanced electronic camera cannot emulate.

Because you have two eyes, your brain receives two views of any subject from slightly different angles. Fused together into a single image, they form a picture that gives you a greater sense of depth than any photograph could provide. Moreover, the camera takes in the whole scene with uncritical interest, whereas your eyes concentrate on the parts of the scene you find most interesting.

The focus of the eye can change so swiftly from near to far objects that all appear equally in focus.

A boy playing may move too fast for the eye to capture his actions. But the camera can freeze every detail – even the ball in mid-air.

The eye

The remarkable versatility of human vision stems from the close link between the eye and the brain. Without our being consciously aware of the process, the brain controls the eye as it rapidly scans a scene to build up a complete picture, focusing on various details and adjusting to differing light levels. At the same time, the brain interprets the information received, making sense, for example, of the changes in scale between objects as they appear to diminish in size with distance. Vision extends through a full 160°, compared with the 45° view of a normal camera lens.

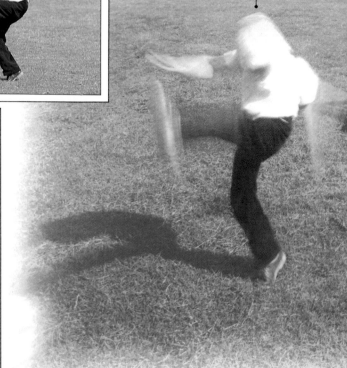

Images from the real world
Photographs may look like
the real world – but do not
duplicate the eye's view,
here represented by a hand-
tinted, retouched image.
This scene in a park around
a mansion includes several
photographic subjects, some
of which are reproduced in
the insets. Each inset picture
captures an image different
from one the eye would see.

The camera, however, can focus only a part of the
scene in one picture. The eye is also a great deal
more flexible in handling extreme contrasts in the
light level. Within the same scene, we can dis-
tinguish details of objects in deep shadow and in
bright sunlight in a way that is denied to the camera.

On the other hand, the camera has certain powers
that are beyond those of the eye. By framing a small
part of the world and thus engaging our attention,
a photograph can make us see things that might
otherwise go unnoticed. And the camera's ability to
freeze motion can reveal details of moving objects
not always visible to the naked eye.

Perhaps the most essential of all these things to
remember is that your eye can notice instanta-
neously what interests you in a scene and ignore the
rest, shifting attention constantly from the whole to
the smallest detail in a changing stream. The camera,
by contrast, fixes the whole scene in the viewfinder
at the moment you press the shutter. You must
provide the discrimination by so directing the
camera that worthwhile images are selected.

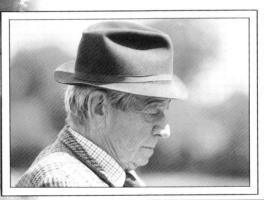

*The man is the subject
for an impromptu portrait.
Notice how the camera has
framed him and isolated him
from his surroundings. The
lens's shallow focus shows
the background as a blur,
removing any distraction.*

The camera
The camera's relative lack of flexibility means that
you must operate it carefully to record effective
images. First, focus must be adjusted for the subject
to appear sharp. The amount of light allowed to fall
on the film must also be just right – and even then
the contrast between light and dark areas in a scene
may be too great for detail to show in both. On the
other hand, the camera records an image fixed in time,
allowing us to keep a record of visual experiences
that we want to remember. Photographs can also show
details of movement the eye could never catch.

Identifying the subject

The first creative step in taking a photograph is to choose the subject. This may seem obvious, but any one situation usually offers a wide range of choices. As a general rule, you should look for a subject that will make a single strong point. The more elements there are in the scene, the more important it is to have a clear idea about what you want the picture to show at the moment you press the shutter. If there are too many details in the viewfinder that do not support the main point, the picture will tend to look untidy – a random snap rather than an effective photograph. As we have just seen, the camera, unlike the eye, is not capable of concentrating on what is interesting and ignoring the rest. Everything in the viewfinder tends to have equal prominence unless the photographer organizes the scene and selects the image to bring out a particular part or aspect of it.

With an inherently disorganized scene – a crowded beach, for example – you need a good deal of skill to produce a broad view that does not look untidy, although the rich variety seen in a panoramic shot may have its own interest. The solution may be to find a viewpoint that allows you to simplify the picture down to a few elements. The photographs on these two pages illustrate three ways of simplifying the picture – moving in on a subject, pointing the camera downward to cut out extraneous background detail, and using a vertical format to concentrate on a single figure.

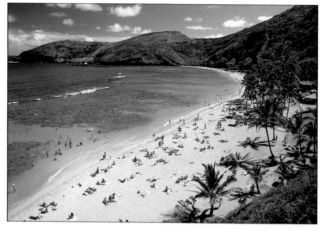

A conventional panorama of the beach records the overall scene without directing your attention to any feature in particular. The subject is full of other interesting photographic possibilities.

The solitary bather (right) is the subject rather than the confusion of surf. Attention is drawn to her by the footprints the photographer has carefully lined up in the viewfinder before taking the picture.

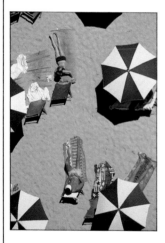

A downward shot from a hotel balcony produces a forceful picture because the photographer chose as a subject the strong graphic pattern of umbrellas and sunbathers.

A close–up of a little girl's delight as a wave leaves her stranded excludes distracting detail and frames her as the entire subject of the picture within a plain blue background.

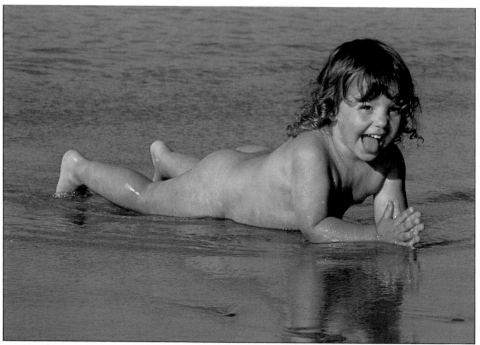

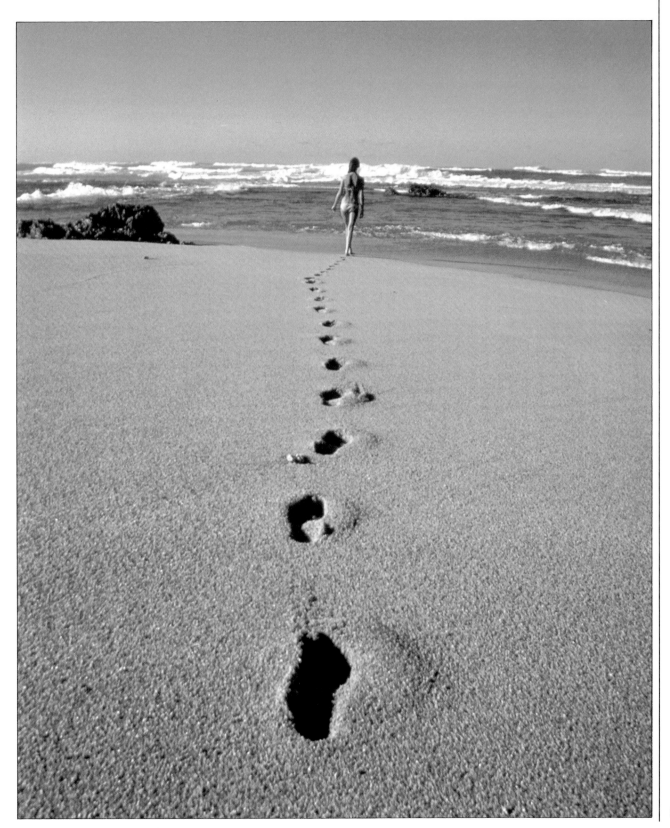

Studied images, fleeting moments

Sometimes the world around us moves so fast that we experience moments of action, excitement or laughter almost as a passing blur. The camera's ability to freeze these moments and record them on film is one of photography's most remarkable attributes and many of the pictures that give greatest pleasure are those that exploit it. But in other photographs what impresses is the sense of absolute stillness and order. This is often the result of the photographer's having had time to think hard about a stationary scene and perhaps rearrange it to make an image that is thoroughly balanced, as in the picture of a hotel balcony on this page.

There are thus two contrasting approaches to taking pictures. On the one hand, an alert photographer can capture those high points and instants in time that may never return – a child's first faltering steps, or a spontaneous burst of laughter in a game. The only way to be sure of catching these fleeting events consistently is to learn to anticipate

them. This means having the camera ready, out of its case, with the film wound on and the controls set to the approximate light conditions and focusing distance. From then on, it is a matter of quick reactions, accurate timing – and a little luck – to be able to capture pictures with the immediacy of the two images at the top of the page opposite.

The other, more considered, approach requires patience together with something of the artist's eye for composition. With time and care, even the simplest objects can be arranged to make an attractive picture and one that perhaps is alive in a different way – because it is charged with atmosphere. The key to successful pictures of this kind is often the lighting, which may be precisely controlled by the photographer. Even natural light can be controlled, if only by standing at a well-judged angle to the subject you are photographing or by waiting for the transformations in a landscape that occur as the sun moves or is covered by clouds.

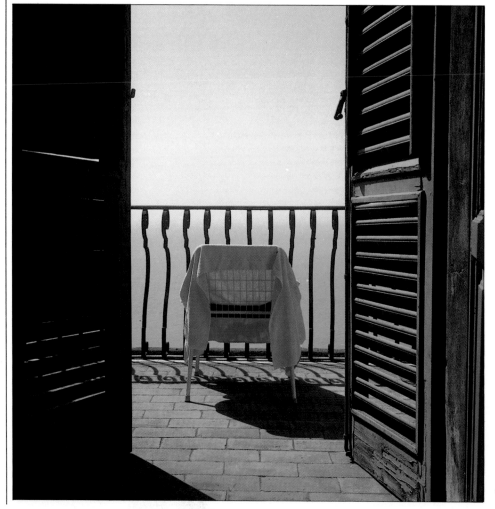

The warmth and peace of a holiday balcony is evoked precisely in an image that seems as casual as the towel draped on the chair. In fact the photographer carefully studied the angle of the chair, adjusted the louvred doors as a frame, and waited until the sun lit the green slats on one side, leaving the others dark.

Landscapes like the one at right may last only seconds as sunlight bursts through storm clouds. The photographer had foreseen the dramatic instant of brilliant contrast.

A gust of wind flips off the cyclist's hat –
but the photographer was ready to catch
the instant of surprise and amusement. He
had preset the camera controls as the
cyclist approached a corner.

Spontaneity and contrivance mix in this
picture by a photographer who gave the
boy the bubble gum so that he would relax
for the camera – and then snapped off a
remarkably natural and relaxed portrait.

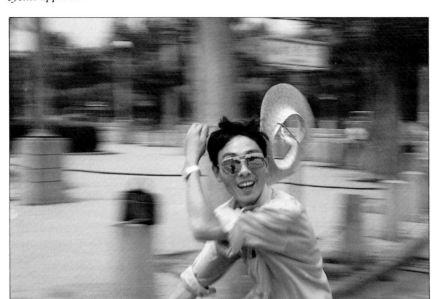

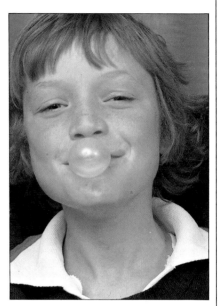

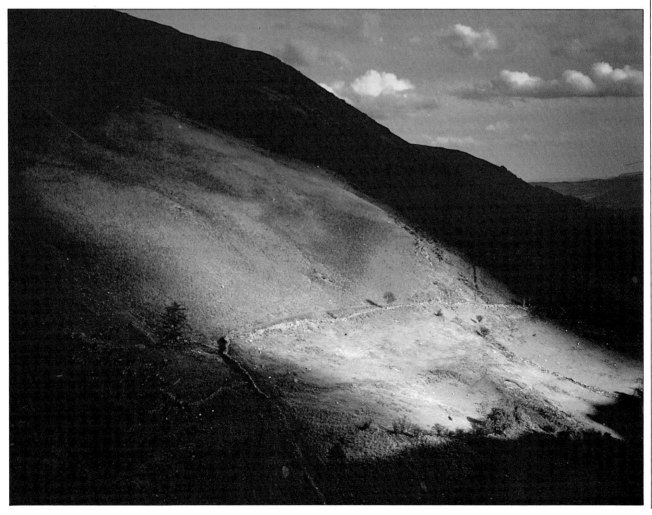

A moment's thought

Many first-time camera users set about taking pictures assuming that everything will fall automatically into place. They aim the lens directly towards the subject, lining up the most important features with the centre of the viewfinder as though the camera were a kind of rifle and the subject a target. This approach will certainly record the subject on film, but is unlikely to produce an appealing image. You will achieve better results by thinking for a few seconds and allowing yourself time to study the scene in the viewfinder carefully. Are there distracting elements in the frame that would be better excluded by changing the camera position? Is a vertical format – used for the shot here of the reflected building – more suited to the subject than a horizontal one? Are there patterns – as in the rodeo picture – that can be used to give the picture a bold visual structure? With practice, this self-questioning process becomes automatic, a rapid sequence of mental trial and error. But for the beginner – and even for the expert – a conscious pause for thought can make all the difference between an ordinary snapshot and a picture with real impact.

A few simple ideas can point the way. First, placing the main subject slightly off-centre in the frame can create a more balanced and visually satisfying effect than composing directly around the picture's centre. The picture of the old woman opposite is a fine example. Pay particular attention to any lines in the scene – they can be used to direct the attention of a viewer around the picture. Strong lines can also affect the mood you want to achieve – diagonals suggest direction and even movement, and are useful for leading the eye into and out of the picture. These are only a few of the elements of composition that you should take into account in making a picture something more than a visual jumble – and many more will become apparent as you begin to develop visual awareness.

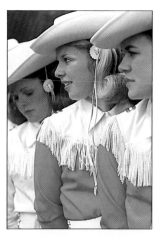

Closing in on this row of cowgirls and using a vertical format eliminates the confused background of a rodeo scene – a simple yet often effective compositional technique. The real subject is the central woman, framed by her two similarly dressed companions. Though they are abruptly cropped by the picture's edge, they are still important in providing pattern and balancing the whole image.

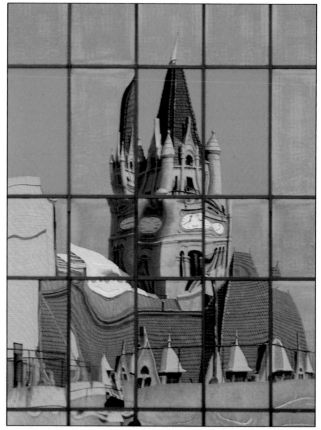

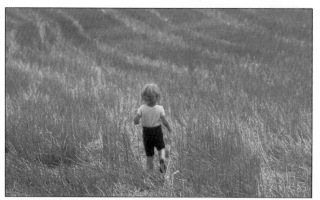

Alone in a wheatfield, the child dominates the landscape although occupying only a small part of the picture area. The photographer moved back and up the hill to keep horizon and sky out of the shot and make the wheatfield into a single, simple background of warm colour.

Reflections can produce intriguing images. Here, amateur Herb Gustafson used observation and forethought to frame the clock tower of the old Federal Courthouse at St Paul, Minnesota, as a reflected vertical in the glass wall of a modern building opposite.

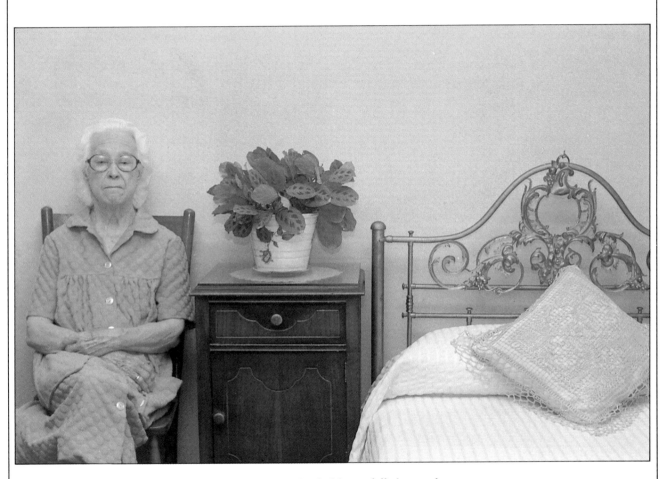

A remarkable portrait of old age, *full of atmosphere,*
relies for its impact on an imaginative composition in which the
subject appears at the very edge of the frame. Centre stage is
occupied by an unassuming potted plant. The visual balance
between the old woman and the bed, with its quilt similar in colour
to her clothing, helps convey the sense of silence and stillness.

Individual vision

Every good photographer eventually develops a way of taking pictures that is personal and distinctive. A few are lucky enough to have such an individual way of seeing that this distinctiveness surfaces from the moment they pick up a camera. To others it comes later, as they gradually begin to master the mechanics of taking pictures.

Experimentation is important, because if you try different approaches you are more likely to discover the type of picture-taking that suits you best. As a starting point, concentrate your interest on a particular subject – you may be drawn to photographing a close companion, or landscapes, or sports, or close-up details. This does not mean you have to stick exclusively to a favourite subject to develop a style. Zeroing in on one target eliminates the uncertainties of less familiar subjects or situations so you can centre your efforts on experimentation and perhaps identify an approach that is essentially your own. You may discover that you are at heart a romantic, like professional photographer David Hamilton, who took the picture of the girl here, or that you are less interested in the superficial descriptive side of a subject than in such purely visual qualities as the rich colours and strong abstract pattern of the fence shown below.

The bold stark pattern of a red fence tilted to march across the sky shows an approach that is the complete opposite of David Hamilton's. Yet for all its impersonality, this image, too, conveys a strong personal style. For this photographer, clean lines, pure colours, and abstract patterns are the essential pictorial elements.

The gauzy portraiture of David Hamilton establishes a style so essentially romantic and so instantly recognizable that it is often imitated. His pictures of girls in flowing spring-like dresses have an innocent air of nostalgia, which he achieves largely by using soft focus, delicate colours and pale, diffused light.

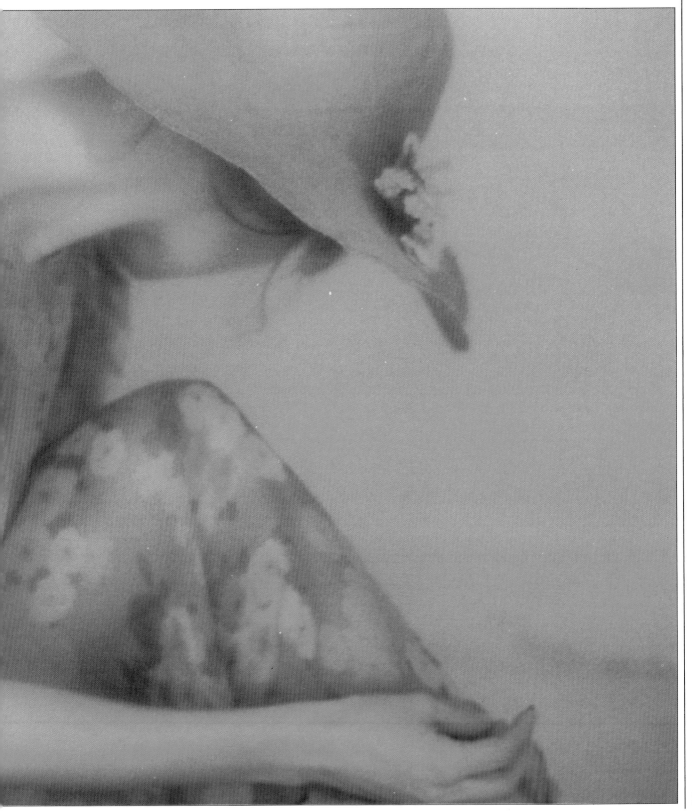

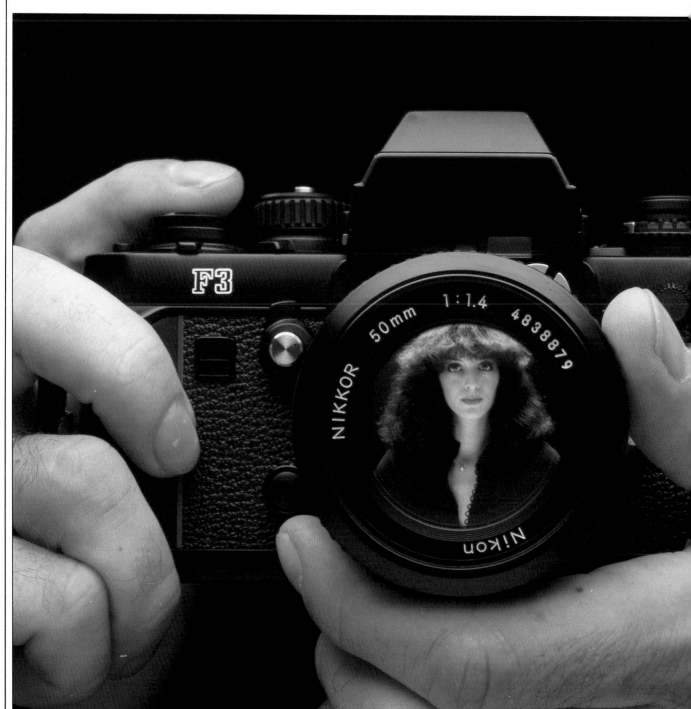

YOU AND YOUR CAMERA

Photography combines two different areas of skill. On the one hand, you need to develop an ability to see creatively, identifying interesting and appealing visual aspects of the world around you. But you also need the ability to translate these photographic ideas into pictures. The camera and film can become efficient servants of your creative impulse – if you learn how to use them.

This is partly a question of mastering essential photographic skills – the principles of camera handling, focusing and exposure that apply to all cameras, however complex or simple. You will handle a camera more confidently if you have a clear understanding of the basic relationship between light, camera and film as explained in the following pages. Try to develop a close familiarity with your own camera also, so that using its controls becomes second nature. The functions and operation of these controls are explained here, but you must study your own camera to see how the principles can be most effectively applied.

Finally, consider your camera in relation to the type of photographs you intend to take. Know the limitations of your equipment and work within them. You will need a camera with a fast shutter to freeze rapid movement, for example. But if you already have one why not go and find some exciting action so as to test the camera's fastest speed? Photography is most enjoyable when you have equipment that extends slightly beyond your current capabilities or needs. As your skill grows, you will value the greater versatility your camera provides.

Good technique is here symbolized by a graphic image that suggests the photographer's sure-handed mastery of the camera's controls in framing and sharply focusing his subject.

Light, lens and film

The word photography means "drawing with light," a phrase that conveys both the creative and the chemical nature of the photographic process. A camera is simply a device for bringing together in a sharp image the light reflected from a scene and allowing it briefly to touch a film material so sensitive that the light leaves a trace, which can be developed into a finished picture.

To form an image, light has only to pass through a pinhole into a dark area and fall on a screen. The modern camera uses a lens and variable-size opening, or aperture, instead of a simple hole, and has a shutter that allows light in for fractions of time, which the photographer can control.

The advantage of a lens is that it can gather and focus light into a sharp, bright image. After collecting the light rays scattering out from every point on the subject, the lens bends them through precisely determined angles to meet again as points. These countless points, varying in colour and brightness; form an image that is an exact copy of the subject's pattern of light. As shown in the diagram, the rays of light travel through the lens in such a way that this image arrives upside down and reversed, with light from the top of the subject brought to focus at the bottom of the image.

The film lies behind the lens on the plane where the light rays form a sharp image when the lens is focused for distant subjects. As a subject gets closer to the camera, its sharp image falls farther and farther behind the lens; hence, the lens must be moved forward in order to keep the image in focus on the film.

When the photographer opens the shutter, light from the subject begins to act on an emulsion coating on the film that contains crystals of silver halides. These salts of silver are extremely light-sensitive. They darken when exposed to light, much as skin tans in sunlight – but infinitely quicker. The light triggers a chemical change in the salts so that they start to form microscopic grains of black silver. Where more light strikes the film, more crystals are triggered. This process, however, is not visible to the naked eye, and the film requires chemical development before an image of the black silver pattern appears. The lightest areas of the subject – such as the sky – look black because they caused most silver to form, while shadow areas that sent no light to the film appear blank. The result is a *negative* image, which can be reversed in printing to make a *positive* image – re-creating the tones (and with colour films, the colours) of the original scene.

Anatomy of a camera

The parts of a camera, reduced to a schematic form, show in essence what a simple apparatus it is – a box for gathering and forming an image of the subject. Cameras come in many different shapes and sizes, but they all operate on the basic principles shown below.

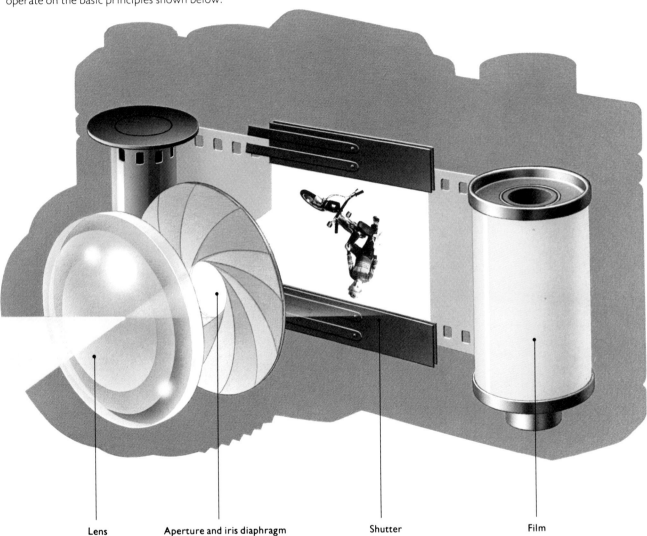

| Lens | Aperture and iris diaphragm | Shutter | Film |

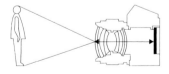

The lens brings the image into sharp focus on the film. Moving the lens forward or back changes the lens-to-film distance, focusing near or far subjects.

The aperture regulates the light entering the camera, usually by means of an iris diaphragm. This is a continuously variable ring of overlapping metal blades.

The shutter controls the length of time light falls onto the film. A common type exposes the film through an opening between two blinds that travel across the film.

The film, held flat at the focal plane, receives the image and records it. The film is wound on after each exposure, permitting a number of shots on each roll.

The camera you use/1

The variety of camera shapes and sizes may seem bewildering, but there is good reason for this diversity: cameras are designed for different tasks as well as different price brackets. Some are ideal for snapshots, and other, bigger cameras are more suited to applications that demand an image of very high quality.

Of all the different types, the 35mm camera is the most convenient compromise between image quality and ease of use. The term "35mm" refers to the width of the film, which comes in a long sprock-etted strip, loaded into a metal cassette. The actual size of a standard 35mm negative is $1 \times 1\frac{1}{2}$ inches – large enough to make quality prints as big as this page, but small enough for the camera that carries it to be reasonably compact.

The term for the most popular type of 35mm camera – single lens reflex, or SLR for short – refers to its viewing system, which makes the camera extremely easy to use. A mirror reflects light from the single lens up to the viewfinder and shows exactly what is going to appear on film. Focusing and composing the picture is thus made simple. In addi-tion, the SLR is highly versatile because its lens is removable and can be replaced by others that give different views or perform specialized tasks.

Although now the most popular type, the SLR is not the only 35mm camera. "Compact" cameras, for example, usually have a non-interchangeable lens, and their functions, including focusing, may be fully automatic. These cameras are even easier to use than an SLR, but are not as versatile.

Similar to the compact is the rangefinder camera, such as the famous Leica. Small and very quiet in operation, these are best in situations where the photographer wishes to go unnoticed. But range-finders – particularly those with interchangeable lenses – are also useful for general photography when rapid focusing is needed.

Shutter speed dial – controls the duration of exposure

Shutter release – starts exposure

Lever wind – advances the film

Frame counter – shows how many pictures have been taken

Self-timer – delays exposure so the photographer can get into the picture

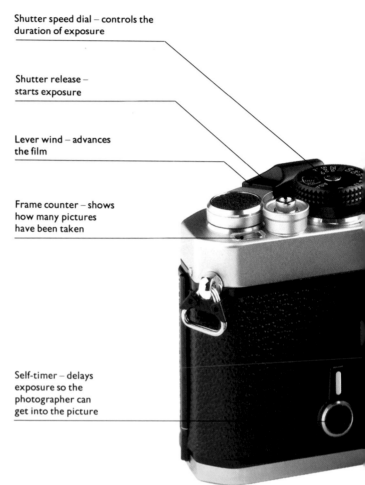

35mm SLR

The distinctive shape of the 35mm SLR is due to its viewing system. The camera is instantly recognizable by the central hump, housing the viewing prism and eyepiece. Modern SLRs are smaller than their predecessors, but they must still incorporate a reflex mirror behind the lens, so they are generally bigger and heavier than non-reflex 35mm cameras such as compacts and rangefinders. SLRs range from simple, manually operated types to highly sophisticated electronically controlled models. Even the simplest, however, incorporates a light-measuring system to advise on exposure. And they can all be used under a wide range of conditions.

SLR viewing system

The mirror and pentaprism in an SLR camera (left) let you see the image formed by the lens exactly as it will fall on the film. Light passing through the lens is reflected by the mirror onto a focusing screen, positioned at the same distance from the lens as is the film. This image is then converted by a five-sided prism (the pentaprism) so it can be viewed right way up and right way round. The mirror flips up out of the way when the shutter is released, thus allowing the light to reach the film.

Pentaprism

Focusing screen

Reflex mirror

Lens

Light path

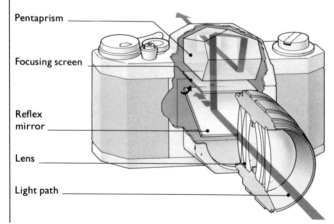

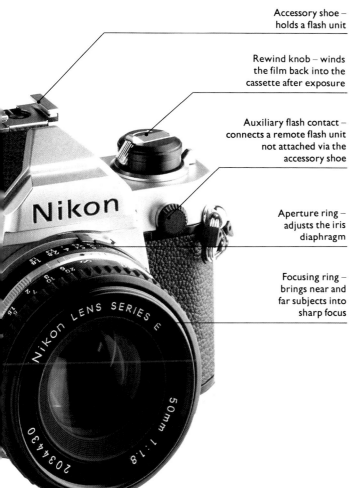

Accessory shoe – holds a flash unit

Rewind knob – winds the film back into the cassette after exposure

Auxiliary flash contact – connects a remote flash unit not attached via the accessory shoe

Aperture ring – adjusts the iris diaphragm

Focusing ring – brings near and far subjects into sharp focus

Rangefinder window – forms a secondary image of out-of-focus subjects in the viewfinder

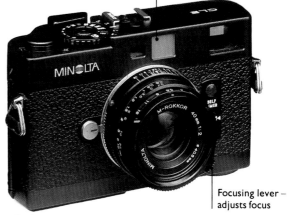

Focusing lever – adjusts focus

Rangefinder camera

These cameras take their name from the quick and easy method of focusing that they employ – they have an optical rangefinder that shows in the viewfinder a double image of out-of-focus subjects. As the lens is focused, the two images unite to form one. Exposure control is generally manual or partly automatic. The model shown here has through-the-lens metering and an interchangeable lens; it is light and compact but versatile.

Twin autofocus windows – admit light to the focusing mechanism

Built-in flash – supplies extra light if needed

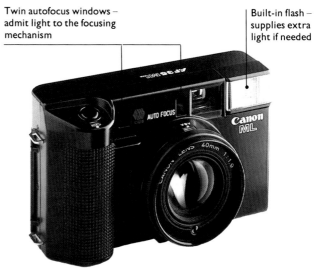

35mm film

The metal cassette in which 35mm film is supplied is almost lighttight, but should still be loaded into the camera out of the sun. The processed film produces prints, or slides in 2 × 2 inch mounts to fit a projector.

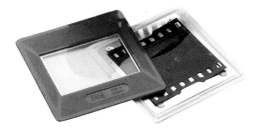

Compact 35mm camera

These simple, lightweight cameras take the same film as SLRs but often have an easy loading system. Exposure controls vary from model to model, but most are automatic. Built-in flash, which pops up for use, is common. Most compacts have a moderate wide-angle lens, which gives a wider field of view and greater depth of field. The compact camera above is typical of the newest models, with automatic exposure, focusing, flash and film advance.

The camera you use/2

Because photographers have such varied require-ments, cameras have evolved in a number of different directions. Although the 35mm SLR can cope with most situations, some people find it too heavy and bulky. Others want a camera that will enable them to see their pictures immediately. And still others, particularly professionals, want the greater technical precision that larger-format cameras can provide.

Pocket cameras, such as the disc and 110 film types shown here, get around the problem of size and weight by using a negative only a fraction the size of the 35mm format. These cameras employ snug-fitting drop-in film cartridges and are so small that they can be carried conveniently at all times. In spite of the inevitable limitations of film size, and general versatility, some 35mm photographers find them useful for snapshots: picture-taking is almost fool-proof and prints are usually of adequate quality up to postcard size.

Instant-picture cameras, though cumbersome by comparison, have different advantages. They elimi-nate the wait while films are being printed. Immediately after you press the shutter, the camera ejects the print. The picture begins to appear within a few seconds and is fully developed in a matter of minutes. These cameras are fun to use at parties and family occasions because everyone can see the results immediately, and if a picture is a failure there is still a chance to take another. Local laboratories can make extra copies of the same image. Professionals wanting a precisely controlled result often use instant-picture film to judge the effective-ness of a scene or a lighting set-up before taking the shot with conventional film.

When the finest quality is more important than ease of operation, some photographers prefer to use a larger film size than 35mm, even though this means a correspondingly larger camera. The most common of these larger films is 120 rollfilm, which produces negatives $2\frac{1}{4}$ inches (6 cm) wide. Cameras that use this film are bulkier, heavier and mostly costlier than smaller formats, and are usually manually operated rather than being automated. Advanced photographers prefer them, though, because they are not too large to be hand-held and yet they produce a negative of fine quality, capable of show-ing sharp detail even when the prints need to be blown up into pictures many times the size of the original negatives.

For near-perfect results, some photographers use large-format technical cameras. These take film supplied in individual sheets, usually no smaller than four by five inches in size. As a result, the cameras are somewhat unwieldy and require real expertise.

Pocket and disc cameras

The small 110 and disc models shown here are sophisticated, with automatic exposure, built-in flash and sometimes a switch to change the lens from wide to narrow angle of view, or from long-shots to close-ups. All of them are easy to load, and some have a folding cover to protect the lens when the camera is not in use.

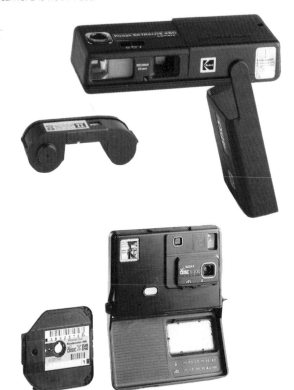

Both disc and 110 cameras are used mainly with colour print film, enlarged to postcard-sized prints. Bigger enlargements look acceptable if the picture is sharp.

Instant-picture cameras

All instant cameras have automatic exposure and a manual control to lighten or darken the results. Some focus automatically, and may have a built-in flash and a capacity for close-ups. The types shown fold flat for easy carrying. For good results, always hold an instant camera steady as the print ejects, and keep your fingers clear of the exit slot.

Rollfilm cameras

The most popular medium-format camera is the 120 rollfilm SLR, which, like the 35mm SLR, uses a mirror to reflect the image up to a focusing screen. Rollfilm SLRs often have special film magazines that allow film to be changed from colour to black-and-white or instant film in mid-roll. Their large film size gives exceptional quality.

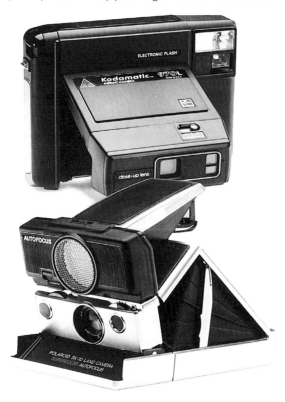

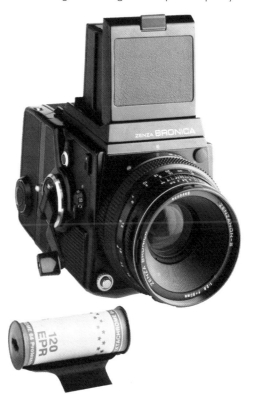

Instant film comes in closed packs that are placed in the camera. The ejected prints are sealed in plastic. The image appears as you watch, colours gradually growing stronger.

Rollfilm gives images $2\frac{1}{4}$ inches (6 cm) wide, but of different heights, depending on the camera type. A square format $2\frac{1}{4} \times 2\frac{1}{4}$ inches (6 cm × 6 cm), as shown here, is the commonest.

What to do first

Nothing is more disappointing than taking a whole series of pictures and then discovering that the film did not wind through because of incorrect loading in the first place. Step one in photography is to load the camera correctly. Then, using the procedures on the opposite page, set the correct film speed – the sensitivity of the film you have put in – and check to make sure that the camera's exposure meter is working properly.

You can load disc and 110 cameras quickly and safely, even in bright sunlight, just by dropping in a new cartridge and winding on to the first frame. But cassettes of 35mm film are not entirely lightproof, so cameras using this film should be loaded and unloaded in the shade or indoors. And although some cameras now take up 35mm film automatically, a leading strip or tongue of film usually has to be carefully threaded onto the camera's take-up spool. After closing the back, there are a couple of ways to check that the film has not slipped out of the spool and that the film is actually advancing when you wind the lever. The simplest way is to turn the rewind knob gently in a clockwise direction. After taking up slack, the film should begin to pull taut, transmitting resistance to the knob. (This is also the best way to check whether you have film in a camera.) You can make doubly sure the film is advancing properly by checking that the rewind knob turns when you wind ahead. Eventually, these simple checks become almost automatic.

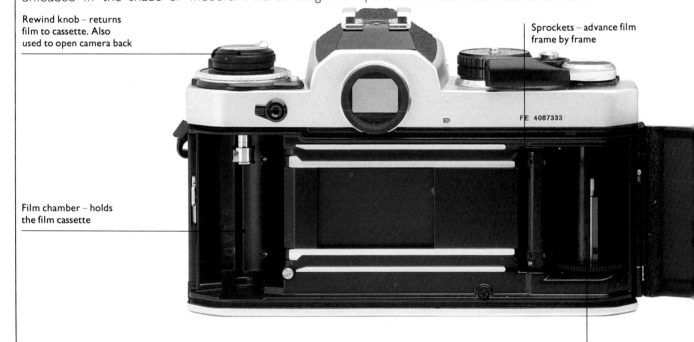

Rewind knob – returns film to cassette. Also used to open camera back

Sprockets – advance film frame by frame

Film chamber – holds the film cassette

Take-up spool – accepts tongue of film in slot

Loading a 35mm camera

1–In the shade, hold the camera firmly by the lens and pull up the rewind knob to open the camera back. Keep the knob raised.

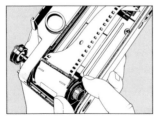

2–Place the film in the left-hand chamber, then push in the rewind knob, turning it until it clicks firmly down into place.

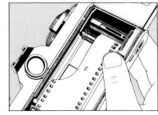

3–Turn the film lip forward and insert the tongue into one of the slits in the take-up spool. Fit the bottom row of holes over the sprockets.

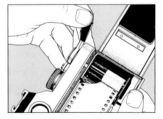

4–Next, click the shutter and wind on to ensure that the sprockets begin to engage both top and bottom rows of perforations.

Checking the meter

Usually you switch the meter on by cocking the shutter (right), by lightly pressing the shutter release, or by using a meter switch. If the meter is working properly, a meter display will be activated, as in the example shown at far right. With more simple models that use a needle indicator, make sure that the needle moves when the camera is pointed at a bright subject. Many cameras have special devices for checking the battery power. On some, a battery check button can be pressed. Sometimes a warning light shows automatically when power is reduced.

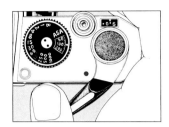

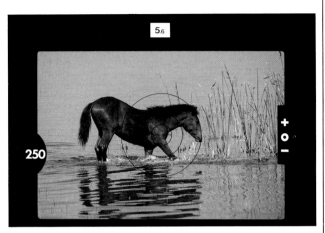

Film perforations – catch on sprockets

Film speed – indicates sensitivity of the film to light

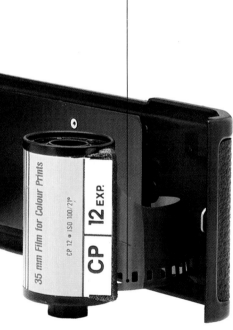

Film expiration date – shows date by which film should be used for best results

5–Close the camera back and continue advancing the film until the number for the first exposure appears in the exposure counter window.

6–To unload, release the rewind catch or button, lift the rewind crank, and turn it clockwise until it suddenly turns more easily.

Setting film speed

The film speed is marked on the film box and on the cassette or cartridge. Some 110 cameras set the speed automatically when the cartridge is inserted. But 35mm cameras have a film speed dial that must be set manually to match the speed of the film loaded. When shooting, check occasionally in case the dial has been moved accidentally.

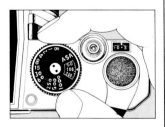

Keeping steady

For sharp, well-framed pictures, you must hold the camera absolutely still while you release the shutter. Camera shake at the moment of exposure is by far the most common cause of blurred or crooked pictures. The sequence of actions involved in bringing the camera to the eye, adjusting the controls and pressing the shutter in a smooth, stable way needs to be rehearsed until it becomes automatic. Experienced photographers are said to think through their hands because they are so familiar with their cameras that they handle them almost by second nature.

To achieve a firm but comfortable camera hold for both horizontal and vertical pictures, you can vary the exact grip to suit your own hands and camera. But you should make sure to cradle the camera securely, with the controls within easy reach of your fingers. While aiming, rest your index finger lightly on the shutter release so you can press it gently and smoothly at the decisive moment. Holding your breath as you release the shutter may help to minimize movement.

Wherever possible, take advantage of any additional support, as shown below. Extra stability becomes crucial when you are making slower exposures – in evening light or dim interiors, for example. Take special care with 110 cameras, because their light weight and flat shape may increase the risk of shake, which can show up in prints enlarged from the small negative.

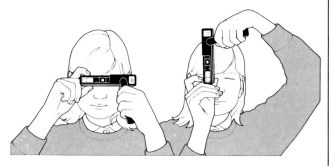

Holding a 110 camera
Some 110s have steadying handles to minimize camera shake. Hold others firmly at each end and remember to keep your fingers clear of the lens. For vertical pictures with built-in flash, keep the flash uppermost.

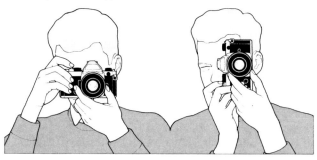

Holding a 35mm SLR
For both horizontal and vertical shots, grip the camera with your right hand, using the index finger to release the shutter and the thumb to wind on. Use your left hand to support camera and lens, and to adjust focus.

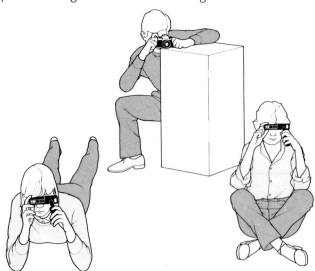

Steadying the shot
Using a standard lens at shutter speeds of 1/125 or faster, working without support is safe enough. Stand squarely, feet apart, with the elbows tucked well into the body. At 1/60, look for some means of steadying yourself: lean against a wall or, for lower viewpoints, try sitting cross-

legged with your elbows on your knees – or lying down with your weight on your elbows. At even slower speeds in dim lighting conditions the camera requires additional rigid support. Rest it on a flat surface or hold it against a wall if you do not have a tripod.

Camera shake

When you are taking pictures in dim light, you will usually need slow shutter speeds to let enough light into the camera. The results may be entirely blurred, as above, unless some support is found for the camera.

Crooked pictures

It is very important to hold the camera straight, especially if your subject has strong horizontal or vertical lines. A sloping horizon or apparently leaning buildings can ruin a picture (above). Make sure that the true verticals, particularly in buildings, are aligned with an edge of the viewfinder frame.

Focusing the image

To achieve sharp images you need not only to hold the camera steady but also to focus it accurately. The camera cannot keep near and far objects flexibly in focus, as the eye does, and the blurring of out-of-focus objects is one of photography's most distinctive characteristics.

In most pictures, the zone that looks reasonably sharp extends for some distance behind and in front of the plane on which you focus the lens. The depth of this zone depends on several factors, including the size of the lens aperture, as pages 44-45 explain. But the diagram on the right, here, shows that one of the most important factors is the distance of the subject from the lens. The closer you are to the subject of your picture, the more carefully you must select the part you want to be most sharp and clear.

To adjust the position of sharpest focus, all cameras except the most simple have a focusing control ring. This moves the lens forward and backward to change the lens's distance from the film. Moving the lens and film farther apart brings into focus objects closer to the camera.

With some cameras, you focus by estimating your distance from the main subject and matching this to a scale of distance markings or symbols around the lens. Because this method of focusing involves guesswork, however, other, more versatile, cameras have systems that indicate clearly in the viewfinder when the image is sharp. The SLR camera uses a precision mirror to reflect onto a screen the image that will appear on the film, allowing you to adjust the lens until the screened image is sharp.

Most SLR focusing screens nowadays are made of finely moulded plastic. At the centre are focusing aids – often a pair of semicircular prisms that split any unsharp image across the middle. As you turn the lens to bring the image gradually into focus, the two broken halves move together to form a perfectly aligned picture.

These twin prisms are together called a split-image finder, and around them – or sometimes instead of them – is a ring of tiny prisms of a similar type. These microprisms have the same effect of breaking up the image, but on a smaller scale, so that the unsharp picture appears shattered into countless shimmering fragments.

Rangefinder cameras have separate lenses for viewing the subject and exposing the film, so they rely on a less direct method of focusing. When you look into the viewfinder, you see a double image of the subject, and you turn the focusing ring until these images move together and coincide. In most autofocus cameras, an electronic eye performs the task of judging when the two images meet, and the lens is automatically adjusted for correct focus.

The focusing control ring
Turning the wide, knurled ring focuses subjects at varying distances (indicated in feet and metres just under the ring). The ring moves the lens farther from the film for a subject only 3 ft away (left) than for far subjects (right), which are indicated by a symbol representing infinity (∞).

How much is in focus?
At close distances, only a very shallow part of a scene appears sharp (red zone above left). If you are taking a head-and-shoulders portrait, for example, at a range of a few feet, the background will blur (ochre area). The zone of sharp focus becomes progressively wider as you focus on more distant subjects (central group) until eventually the lens brings into focus objects in a zone stretching far back from the middle distance.

SLR focusing
The split-image finder focusing screen – which appears as a bull's-eye in the unfocused image at right – makes SLR focusing easy. Look for a horizontal or vertical edge near the centre of the subject (here the window frame) and turn the focusing ring until the two split halves in the circle coincide (below). Alternatively, focus until the microprism clears.

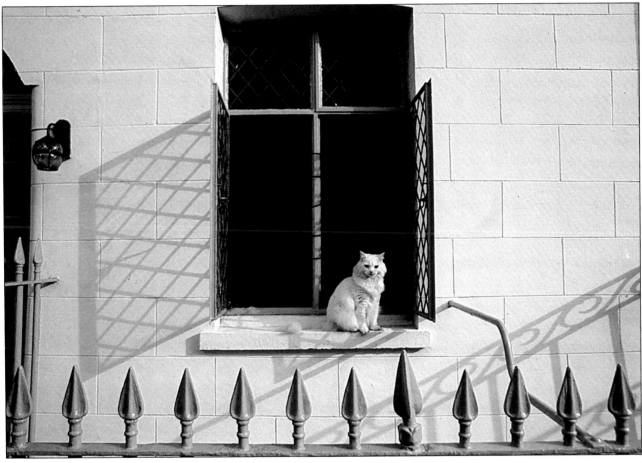

Rangefinder focusing
The typical rangefinder system shows a double image in the viewfinder when the subject is out of focus (above left). The difference between this and the single image of a correctly focused subject is clear enough for focusing to be rapid and sure even in dim light – when focusing an SLR sometimes becomes difficult.

Autofocusing
The compact autofocusing camera here has a tiny motor that moves the lens to focus on the area indicated by a distance measuring system. This system compares two differing views of the nearest object in the centre of the camera's viewfinder – doing this so quickly that it seems to be virtually instantaneous. Other systems bounce sound or infra-red rays off subjects. Some SLRs have a support autofocus system with viewfinder lights (bottom right) acting as focus guides.

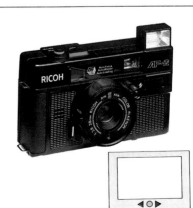

The shutter

The shutter is the basic picture-taking control on a camera. Releasing it smoothly, at just the right moment, makes all the difference to a shot. Never hurry – the secret of sharp, well-timed pictures is to be ready, and anticipate the moment, squeezing the release gently when you feel everything in the viewfinder is perfect.

Choosing the right shutter speed is just as important. It affects both sharpness and exposure. The numbers on the shutter speed dial are called speeds but they are actually exposure times – fractions of a second for which the shutter will stay open, exposing the film to the light image projected by the lens. For simplicity, 30 is used to mean 1/30 second, and 60 to mean 1/60 second. The higher the number, the faster the speed and the briefer the exposure. At each higher setting, exposure time is halved. Most single lens reflex cameras have a fastest speed of 1/1000 second, but SLRs with a top speed of 1/2000 second and even 1/4000 second are also available.

For a sharp picture, the fastest practical shutter speed is the safest to use, because the less time during which light from an image falls onto the film, the less time there is for any subject movement or camera shake to blur the photograph. Camera shake while the shutter is open is probably the commonest cause of disappointing pictures.

A safe working speed for handheld shots with a normal lens is 1/125 second – fast enough to stop camera shake and freeze all except rapid motion. Close-ups and shots with telephoto lenses need faster speeds – 1/250 or 1/500 second – and so do active scenes such as children playing.

In practice, the choice is often limited by the lighting – in dimmer light longer exposures are needed, and this makes it difficult to freeze movement. On dull days or indoors, speeds below 1/60 second may be required for an adequate picture, and then it is necessary to provide the camera with a support – if possible, use a tripod and a cable release.

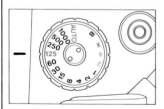

Shutter speed control
Shutter speed is usually set by means of a dial on top of the camera (above). Other systems include a ring positioned around the lens mount.

The shutter scale
The range of shutter speeds offered by your camera will include most of the speeds on the scale at right. The more versatile the camera, the more speeds will be offered. The dial at left, for example, runs from 4 secs to 1/1000. Other settings offered are "B" for longer exposures, "X" for flash synchronization and "Auto" (sometimes "A") for automatic exposure.

At slow shutter speeds, any movement blurs the image. In the picture below of a girl roller skating in a park, a speed of 1/30 dissolves her whole body into streaks of colour.

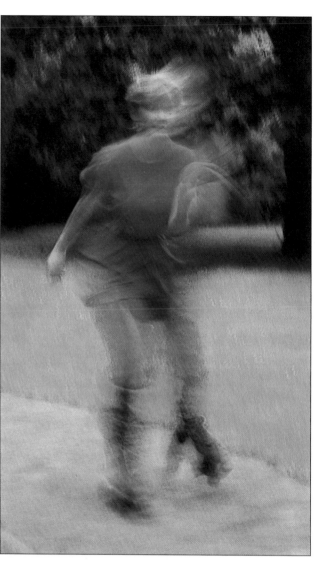

Slow speeds				
4 secs	2 secs	1 sec	1/2	1/4

Camera handling

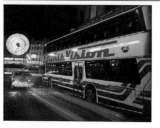

Slow speeds are suitable not only for static subjects but also when you want to suggest movement impressionistically. The lights of city traffic at night (left) have been blurred into vivid, rushing streaks by using a shutter speed of 1/4.

At medium speeds (*here 1/125*), *there is still some blur, but it shows mainly in the hands and feet – the parts of the body that are moving at greatest speed.*

Fast shutter speeds will freeze all movement. At 1/500, the girl's body, hands and feet are sharp, even though she is racing toward the camera at full tilt.

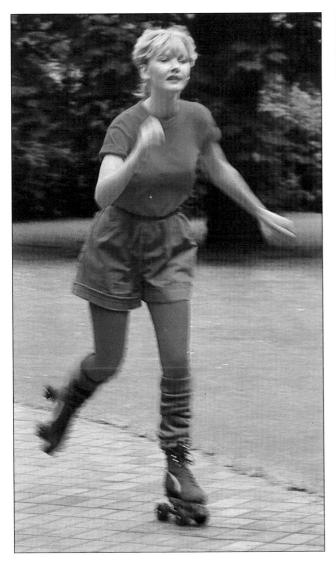

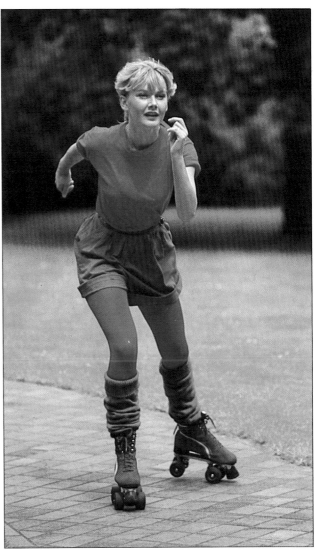

			Medium speeds		Fast speeds			
1/8	1/15	1/30	1/60	1/125	1/250	1/500	1/1000	1/2000
Camera support needed		Extra care required with handheld camera		Safe to handhold with normal lenses	Safe to handhold with telephoto lenses			

Medium speeds are the usual choice for everyday scenes, and are also needed for flash pictures, such as the one at left. Many cameras have a speed marked X (usually 1/60 or 1/90). When you set the dial to this, the flash and shutter are synchronized.

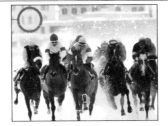

Fast speeds of above 1/500 are useful for action pictures or with high-powered lenses, which magnify movement and are difficult to hold steady. The flashing hooves of the racehorses on the left were frozen with a shutter speed of 1/1000.

The aperture

The aperture is the opening of the lens through which light enters the camera. On all but the simplest cameras, you can increase or decrease the opening, usually by means of an iris diaphragm, and this is one of the principal ways of controlling how the picture will look. Widening the aperture allows more light to reach the film. Together with shutter speed (which controls the amount of time during which light can affect the film), this determines the exposure – the total amount of light that reaches the film. The other important function of the aperture is that it affects depth of field – the zone of sharp focus in a scene, extending from the nearest element that is sharp to the farthest. Because wrong focus is less noticeable if the effective lens area is reduced, depth of field increases as aperture size decreases.

Aperture is adjusted in a series of click stops, each full stop doubling or halving the amount of light let in. These stops are marked on the aperture control ring in a coded numerical series called f-numbers, running in a standard sequence f/1, f/1.4, f/2, f/2.8, f/4, f/5.6, f/8, f/11, f/16, f/22. The numbers get bigger as the aperture opening gets smaller. F/16 is thus a small aperture, letting in much less light than f/2. No matter what size or type of lens you have, the system ensures that the same f-number will let the same amount of light reach the film.

The lowest f-number shown on the aperture control ring indicates the largest aperture a particular lens can provide, often between f/1.4 and f/2. To let you view the subject clearly, modern lenses usually stay open at maximum aperture until you press the shutter, then the aperture "stops down" to the selected f-number. This means that you have enough light to focus the main subject sharply while you are viewing – but that near and far objects may look fuzzy, because the aperture has not yet stopped down and improved the depth of field. Most cameras now have a preview button (below). When pressed, it alters the image in the viewfinder to show the actual extent of sharpness.

SLR preview button
This is often on, or by, the lens. You simply press it to preview the true depth of field of the aperture.

Aperture scale
The sequence of f-stops is shown at right, light being halved at each setting. The pictures below the scale show the effect on exposure if the aperture is reduced without slowing the shutter speed. By using a preview button, you can see the image darkening at each stop as the aperture steadily cuts the light admitted.

At maximum aperture, used for the picture below, depth of field is very shallow. Only the main focused subject is sharp. Foreground and background are blurred.

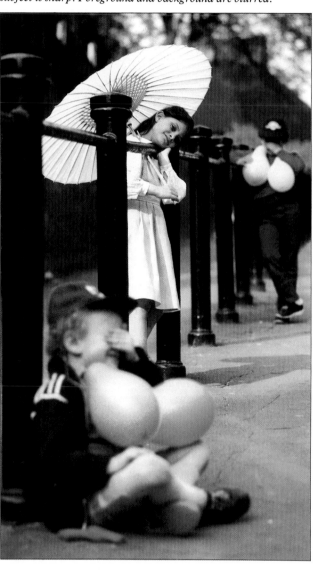

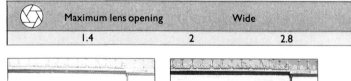

	Maximum lens opening		Wide
	1.4	2	2.8

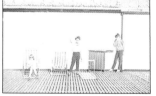

f/2 Bright image, shallow depth of field

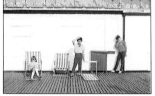

f/2.8 One stop down

At a medium aperture, depth of field is greater. The farthest child and most of the background are sharp. But the boy in the foreground is still out of focus.

At minimum aperture, depth of field is so great that even the foreground boy is sharp. The shot needed a slow shutter speed at this aperture, so any movement would have blurred.

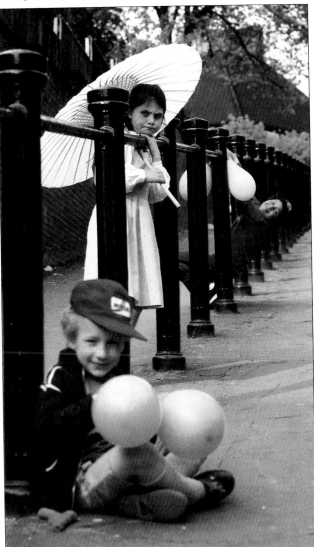

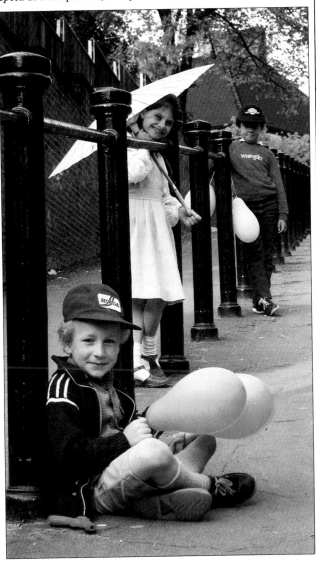

Medium			Small		Minimum lens opening
4	5.6	8	11	16	22

f/4 Two stops down

f/5.6 Three stops down

f/8 Four stops down

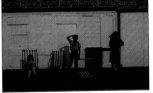

f/11 Five stops down, good depth of field

The right film

In selecting what kind of film to put in the camera, the broad choice lies between film for colour prints, for colour slides or for pictures in black-and-white (overleaf). Within these categories are many different types of film – it is easier to take successful shots if the film chosen matches the subject and lighting conditions as precisely as possible.

The most important property of a film is its sensitivity to light – the film speed. Slow films need much more light to form a usable image than do fast films, which are highly sensitive. This means that you can more easily take pictures in dim light with fast film. In brighter light, fast film allows you to select a fast shutter speed or a small aperture if needed. However, fast films have one drawback: the grains that make up the image have to be large so that they react quickly to a limited amount of light, and when the picture is blown up they show as gritty texture. Slow films have smaller grains and can record finer detail, but unless the light is bright, they may force the photographer to use an unsuitably slow shutter speed or too wide an aperture. In average daylight, films of medium or medium-fast speed offer a good compromise. Fast films are an advantage in poor light or for action photographs requiring fast shutter speeds. Slow films are useful for static, detailed subjects, such as still-life or architecture.

Until recently, film speed has been indicated by an ASA (American Standards Association) number, or by a DIN (Deutsche Industrie Norm) number, and the ASA number appears first in the new ISO (International Standards Organization) system of designating speed. Thus, a marking ISO 100/21° (or simply ISO 100) indicates ASA 100 or 21°DIN – a medium speed. Each doubling or halving of the ISO number indicates a halving or doubling of speed, changing the exposure required by one full setting on either the aperture or shutter speed scales.

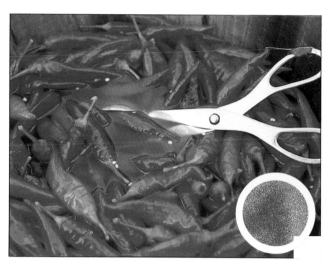

For fine detail, as in this shot of a tub of chillies in a market stall, slow film is best. the Kodachrome 25 film for slides used here has extremely fine grain (seen in the inset microscopic enlargement), and many professionals like it.

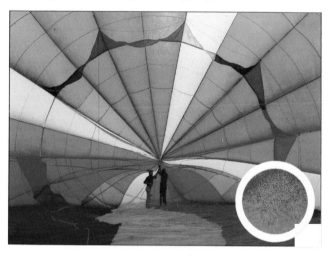

In average light, medium-speed film works well, needing not too wide an aperture and showing little grain (inset). This picture of the interior of a partly inflated hot-air balloon was shot on Ektachrome 64 film for slides.

Film speed
The film speed rating and other details are clearly marked on the box, as at left. Kodacolor VR400 film – a fast film for colour prints – takes its name from the ISO speed rating, which is numerically the same as the old ASA rating. You set the camera to the film speed by lining up the corresponding number on the rewind knob or the shutter speed dial (bottom left). The guide to film speeds (right) shows the range and differing sensitivities.

	ISO	Slow		
Color prints				
Color slides	25		50	64
Black-and-white	25	32	50	

Slow film (ISO 25) can be bought only in black-and-white or colour slide form. Choose it whenever fine detail is important, provided you have strong light or can give a long exposure.

Medium-speed films (ISO 50 to 100) offer fine-quality results but can still be used in below-average lighting conditions. They are available in colour and in black-and-white.

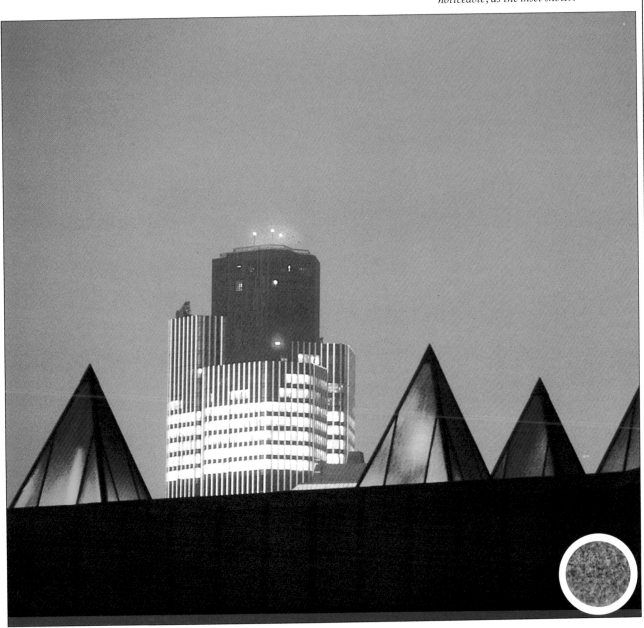

Dim light or fast action calls for fast film. There was just enough light on this modern building at dusk for a handheld picture on Ektachrome 400 film. In big enlargements, however, grain is noticeable, as the inset shows.

				Fast
100	200	400	1000	
100	200	400		
100	125	400		1250

High-speed films (up to ISO 200) are useful when the light is changeable and for many action subjects.

Very-high-speed film (ISO 400) is useful in a wide range of situations, from poor light to rapid action. The results are usually good, and this film is now very popular.

Extremely-high-speed films (above ISO 400) are useful only when light is too low for any other type. They tend to be grainy and are used relatively seldom.

Choosing black-and-white film

Why should anyone use black-and-white film? After all, it is now only slightly cheaper than colour and the bright hues of nature seem a lot to sacrifice. But black-and-white clearly does have a great appeal, and is the chosen medium of many good photographers. What this film lacks in colour, it gains in dramatic impact. Whereas the variety and vibrancy of colour sometimes complicate the appearance of a scene, black-and-white has a graphic simplicity that is well shown in the picture on the opposite page — an ability to convey mood, form and pattern solely in tones of light and dark. You can learn important lessons in photography by using this film, because it is one step farther removed from the real world. Without colour you can more easily concentrate on composing with light, developing a new and valuable way of seeing the world around you.

Black-and-white film has other, more practical advantages. Processing is simple, allowing both development and printing to be carried out at home with relative ease. The equipment needed is neither expensive nor complicated. And home processing allows total control over the final image, including subtle adjustment to the quality of the print.

Black-and-white film is also still available in a wider range of speeds than is colour film. Very slow film (ISO 32 or less) is useful for copying prints onto a new negative or for photography requiring fine detail. Using such film, big enlargements can be made without graininess appearing. At the other end of the scale, ultra-fast film of ISO 1250 will cope with very dim light or fast-moving subjects.

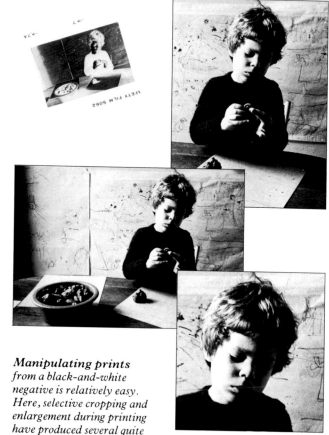

Manipulating prints from a black-and-white negative is relatively easy. Here, selective cropping and enlargement during printing have produced several quite different portraits of a boy from a single negative.

Difficult lighting conditions are much less of a problem in black-and-white than in colour. The superb versatility of monochrome is evident in the evocative portrait of a little girl (left) taken on fast film in low light. The print still contains a full range of delicate tones.

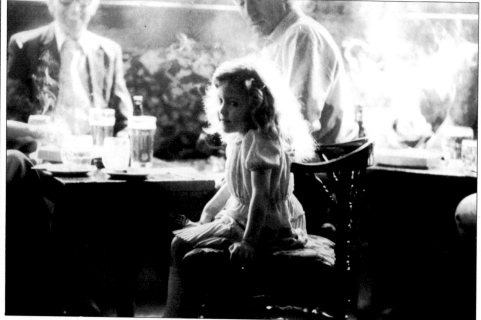

Tone and texture create a powerful abstract image in this high-contrast picture of sand dunes (right). Black-and-white concentrates attention on such qualities.

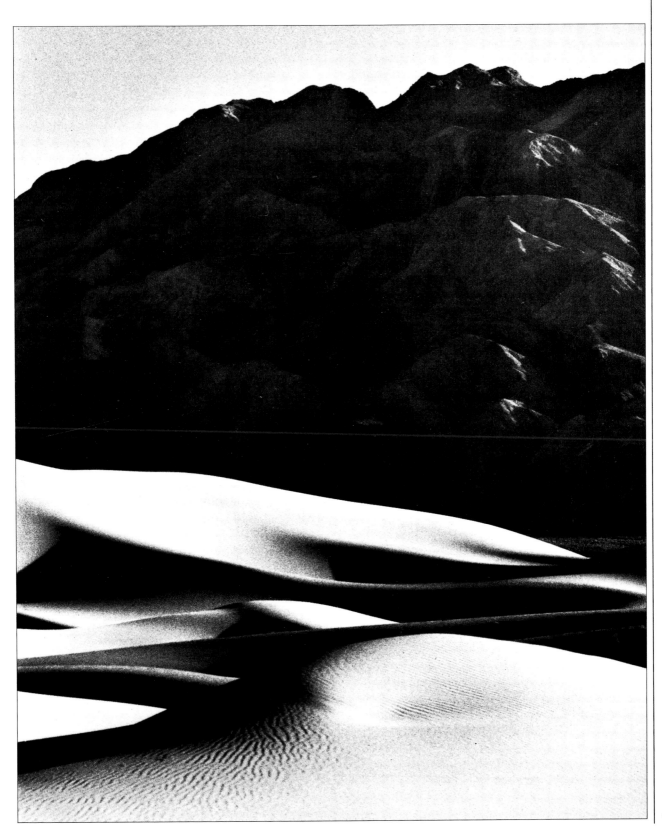

Prints or slides?

There are two broad categories of colour film — print and slide. Print (or negative) film yields a negative image from which prints are made. Slide (or transparency) film gives positive transparencies that can be put into cardboard mounts and viewed by placing them in a slide viewer, using a viewer-projector, or projecting them onto a screen.

Print film is far more popular, mainly because prints are more convenient to look at than slides, and you can display them easily in frames or albums (below). Another advantage is that the printing stage offers an opportunity to correct inaccuracies of exposure. During printing you can also compensate for the unwanted colour effects that result when pictures are taken with daylight colour film in mixed artificial light, and, for example, come out looking unpleasantly orange or green.

Slides, on the other hand, have superior colour quality, with more brilliance, subtlety and depth. They are generally preferred by professionals because they are more suited to reproduction in books or magazines. Even for the amateur, slides can offer greater realism; with a projector, they can be shown greatly enlarged, re-creating scenes on a convincing scale. It is also easier to judge the quality of a slide than that of a negative.

Some photographers take their pictures on slide film, then select the ones they want made into prints, either sending them to a processing laboratory or converting them in a home darkroom. But slide film does demand accuracy in selecting exposure, because you can make only very slight corrections in processing or printing compared to those possible with print film.

False colours will appear when pictures are taken on daylight slide film in artificial light other than flash. However, you can buy films specially balanced to avoid such colour "casts." These special films are compatible both with photographic tungsten lights and with the light from household light bulbs.

Print quality
To print well, a negative should look sharp like this. Because hues are reversed, evaluating the likely appearance of the finished print can be difficult.

Different results are possible from a negative, as shown above. If you are dissatisfied with the results when your pictures come back, ask for corrected reprints. The top two prints above have unacceptable colour errors.

Colour prints
You can keep prints in a number of different ways. Mounting them in an album not only displays them well but also keeps them clean and flat. You can have special shots enlarged and framed. Remember to store negatives carefully in a dry, cool and dark place — you may want more prints from them later.

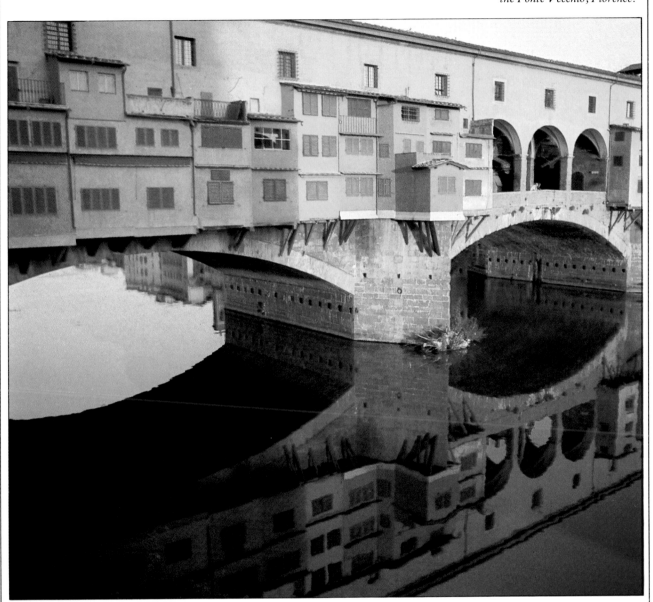

Viewing slides

Projectors for slide shows range from simple hand-operated models to magazine-loaded autofocus models as shown at left. If you do not have a screen, a taut sheet, a large piece of white cardboard or even a flat-finish white wall will make do. As an alternative to projecting slides, you can look at them in a simple slide viewer.

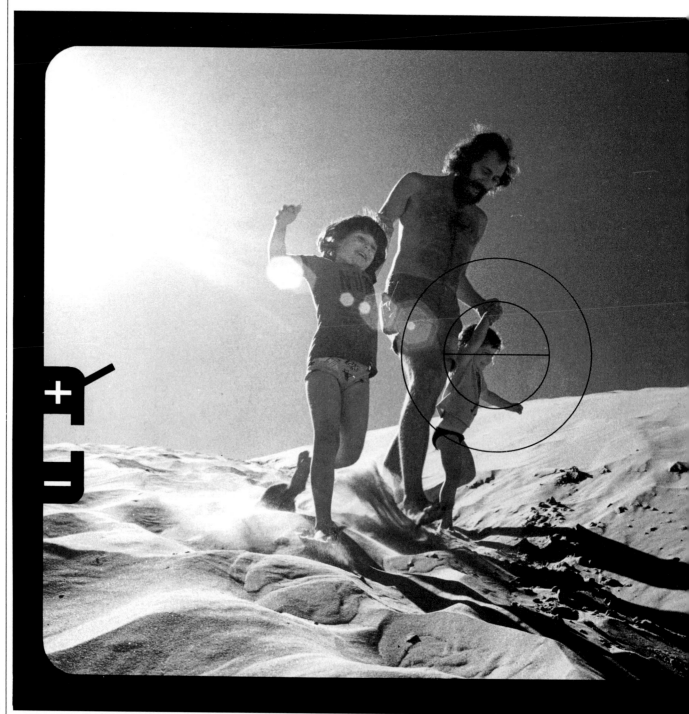

GETTING THE EXPOSURE RIGHT

Modern cameras simplify exposure control. Their automatic systems of measuring and regulating the light that enters the camera do most of the work for you. But the camera will not always get it right, because no amount of technological wizardry or computerized circuitry can produce just the picture you want in every situation. Camera systems work to fixed rules, whereas exposing the film often involves a creative choice. In the final analysis, you must yourself decide how you would like the picture to look and, if necessary, overrule the automatic system.

A good camera metering system aims to provide an exposure that is technically correct – one that offers a compromise between the amount of light needed for dark and light areas of the scene. Usually, the result will look fine. Sometimes, however, a particular part of a scene is more important to you than the rest. The camera cannot deduce this, and in settling for an average exposure may over- or underexpose the key area of your composition. This is where your creative choice comes in. Whether you have an automatic or a manually controlled camera, learn to interpret the distribution of light in the scene, and then decide which combination of aperture and shutter will produce the effect you want.

Sun behind the subject makes exposure hard to judge. The camera's meter is bound to read the bright sky and indicate an exposure setting that will cut down the light. In such situations you have to override the meter – as the photographer did here. The amount of light is just right for the three figures, although the meter needle indicates overexposure. With less light, they would have appeared only as silhouettes.

Controlling light

The light reflected from the world around us varies enormously in intensity. On a sunny day, the scene may be several hundred times as bright outdoors as indoors. Our eyes quickly adjust to these different levels of brightness, but film is not as versatile – it needs a precisely fixed amount of light to form a good image. To get correctly exposed pictures you have to control the light that enters the camera, by first measuring the brightness of the scene and then adjusting your aperture and shutter speed until the quantity of light hitting the film exactly matches the film's sensitivity.

Both shutter and aperture halve or double the amount of light reaching the film each time you adjust their control scales by one full step. Thus, controlling the light is a simple matter of increasing or decreasing either the shutter speed or the size of the aperture. If you balance an increase of shutter speed against a decrease of aperture (or vice versa) the total amount of light reaching the film remains constant. As the diagrams below make clear, several different combinations of aperture and shutter speed can give you the same effective exposure.

This is not to say that each combination will produce the same image. In the picture of wine flowing into a glass at bottom left, a fast shutter freezes the movement, but a wide aperture throws the background out of focus. Conversely, as the shutter speed slows and the aperture narrows, the decanter in the background comes into focus but the flowing liquid blurs. Varying the aperture and shutter speed thus gives you creative control over the picture.

In very bright light, there may be a wide range of possible shutter and aperture combinations. But in dim light your choice will be more restricted. The photographer of the mother and child at the foot of the opposite page, for example, could not use too slow a shutter without blurring the picture, and had to choose the widest possible aperture to deliver enough light to the film.

Aperture and shutter speed
These two controls determine exposure in much the same way as length and diameter affect volume: though the disc representing light on the left is short and fat, it has exactly the same volume as the long, thin stick of light on the right – a long exposure at a small aperture.

Think of exposure as an hourglass – just as the same amount of sand runs more quickly through the hourglass on the left, so doubling the aperture lets through the same amount of light in half the time.

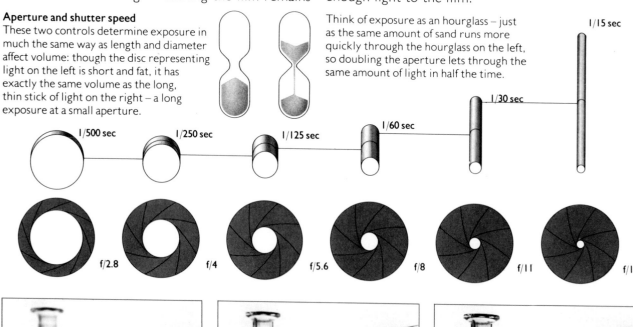

Wine splashing into a glass appears motionless at 1/500, but the brief exposure forces the use of a wide aperture, so there is little depth of field.

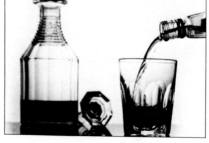

1/60 at f/8 is a good compromise – the film gets the same exposure, and the decanter is sharper, although the wine now shows signs of movement.

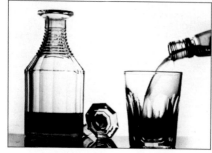

At f/16, the whole image is in focus, but getting correct exposure at this small aperture means using a speed of 1/15 – so the pouring wine is blurred.

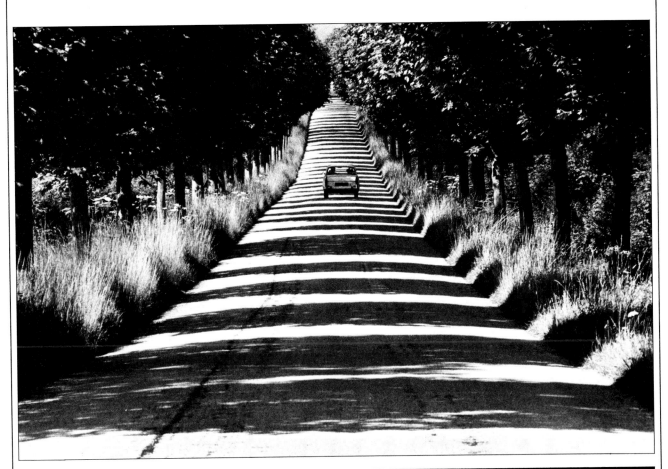

Summer shadows cut a bold pattern of lines on the road, and draw your eye toward the car in the middle distance. The bright light gave the photographer plenty of freedom to choose shutter speed and aperture, so it was possible to keep the picture sharp from foreground to background by using a shutter speed of 1/250 and an aperture of f/11.

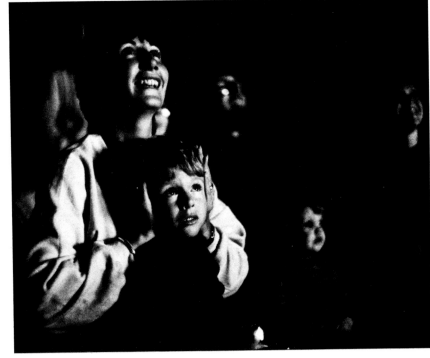

At a firework display there are far fewer choices – here the photographer needed a shutter speed of 1/125 to keep the group sharp, so he set the lens to its widest aperture to make the most of the dim light. He had to forgo depth of field.

Measuring light

Most modern cameras have some form of built-in light metering system that measures the brightness of the scene by means of light-sensitive cells, relates this to the film speed you have set, and either makes or recommends an appropriate exposure setting. When you point the camera at a subject and trigger the meter, a viewfinder display indicates which combination of shutter speed and aperture will provide a suitable exposure. The display may show actual settings or, by means of a moving needle or a flashing light-emitting diode (LED), guide you in adjusting settings. Some SLRs, and other versatile cameras, have through-the-lens (TTL) metering: cells inside the camera read the light after it has passed through the lens.

Meters indicate "correct" exposure as one that will record the subject in a mid-tone, between light and dark. The intention is to provide maximum detail, and an exposure suitable for most subjects. As a result, if you aim the camera at a sunlit wall the meter will select an exposure that will show the wall mid-grey in tone. If you point it at the same wall in deep shadow, the meter will recommend more exposure – again trying to show the wall mid-grey. Normally, however, in a scene of sun and shadow, the highlights are almost white, shady areas are dark and only some areas are mid-grey. Meters vary in the way they cope with this. They may simply average out the brightness of the whole image, but often they weight the average toward areas of the frame that are usually most important in pictures – the centre and lower half. Some allow "spot metering," taking the reading from a small central area of the viewfinder that you aim at the part of the image where you want most detail. The secret of successful exposure decisions is to understand how your particular meter reads a scene and to visualize in advance how you want the picture to look. No matter how sophisticated your camera, you alone can make the creative decisions.

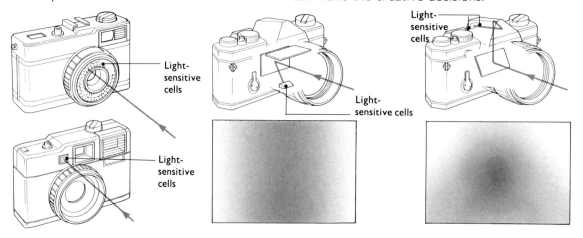

External metering (above)
Simple cameras incorporate the light-sensitive cells of the metering system either on the lens or in a window on the body to read reflected light.

TTL film plane metering (above)
Cells placed internally, near the film, read the actual light that forms the image , averaging the reading across the frame – with a slight central bias.

TTL centre-weighted metering (above)
Many systems give greater weight to the centre and lower half of the image in averaging the light reading. The cells are usually in the pentaprism.

Handheld meters

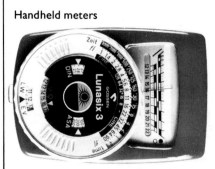

Handheld meters allow more precise readings. The meter can be pointed at the subject, or from the subject back toward the camera itself. The meter's calculator dial then displays a choice of aperture and shutter combinations.

Understanding your meter
A centre-weighted meter gave perfect exposure for the skin tones opposite right, because the subject's face and arms filled the area of the frame given priority in this type of meter's system of averaging light. With a meter that measures light equally over the whole scene, this kind of shot is harder to get right. The bright sky behind the subject may influence the meter to indicate less exposure than the main subject needs. To avoid making errors you must know your own meter.

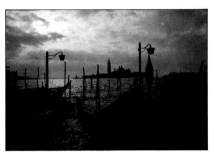 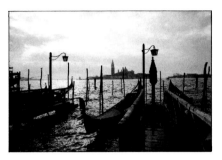 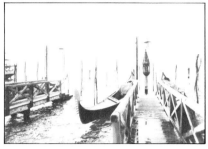

 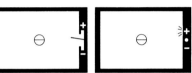

Underexposure
When the needle swings low, or the LED by the minus sign glows, the exposure is too little and the image too dark.

Correct exposure
When the needle is level, or the LED by the zero sign glows, the exposure is correct and detail will be good.

Overexposure
When the needle swings high, or the LED by the plus sign glows, the exposure is too great and the image too light.

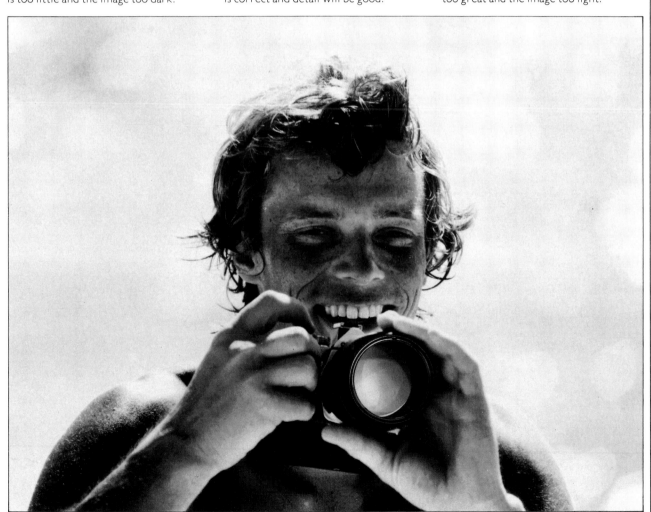

Manual and automatic/1

The systems of measuring light built into cameras are designed to help you avoid making mistakes. They allow you to take pictures in a very wide range of lighting conditions with consistently accurate exposure. At the same time, there are great differences in the operation of cameras with through-the-lens metering, chiefly between manual and automatic models. There are even three separate types of "automatic exposure" cameras: fully automatic, aperture priority and shutter priority. Simple cameras may offer only one option but contemporary SLRs usually offer at least two – a priority system and a means of setting the exposure manually.

With fully automatic metering, the camera determines the exposure and sets both aperture and shutter. Complex electronics are involved, but operating these cameras is simple. On the other hand, you cannot vary the exposure, focus selectively, or control subject movement with shutter speed. Fully automatic cameras are thus more suited to snapshots than to creative picture taking.

The automatic systems relying on priority metering are much more flexible. You set either the shutter speed or aperture you require (depending on which of these two is given priority by the type of camera) and the camera then automatically sets the other control for correct exposure. This allows creative choice, yet frees you from making the final exposure setting so that you can concentrate on the subject. If the light changes at the last moment, the metering system makes the final adjustment.

Aperture priority, with which you set the f-number yourself, gives you control over depth of field and is helpful for landscapes, close-ups or other shots requiring great depth of field. Alternatively, you may want to use a large aperture to restrict depth of field deliberately.

Shutter priority gives you greater control of movement. You can set the shutter speed that will record a moving subject sharply – vital with action shots. With either type, you can in fact control both settings. With an aperture priority camera, for example, the shutter speed selected by the camera shows in the viewfinder display. Therefore, you can always adjust the aperture until, in compensation, the camera switches to the speed you want.

With manual exposure control, you can choose any combination you want, and you can even override the meter. This great flexibility and direct personal control can be very useful in unusual lighting situations and when you want a particular effect, such as the deliberate overexposure in the picture at right. Even if you do not always want to set the controls manually, a manual mode on an automatic camera is essential if you want to extend your range.

Aperture priority automatic

Set the aperture ring to the f-stop you want for depth of field, here f/11.

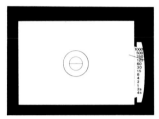

The camera then sets the speed and shows it on the viewfinder scale 1/125.

Shutter priority automatic

Set a shutter speed to control subject movement, here 1/250 on marker at left of dial.

The camera sets the f-stop and shows it at the top of the viewfinder display (f/8).

Manual control
Set either the f-stop or shutter speed and adjust the other control while looking through the viewfinder. In the viewfinder at right, the exposure is correct when a light glows next to the "0."

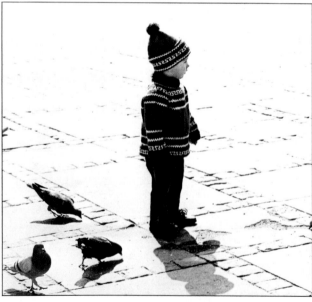

Creative control is needed with some subjects. Using a manual camera, the photographer could set the controls to overexpose the pavement and stop the little boy appearing as a silhouette.

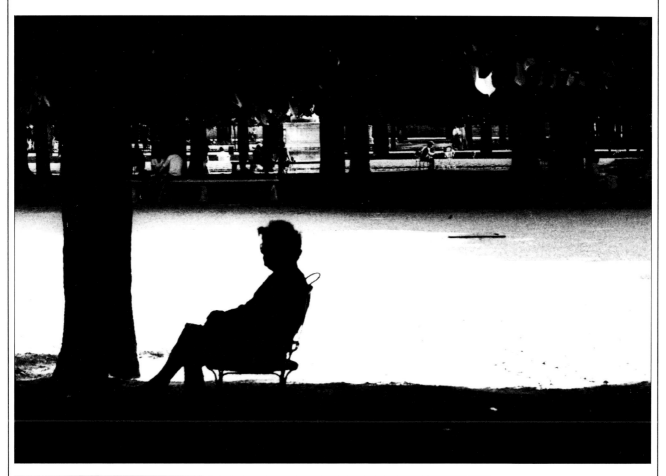

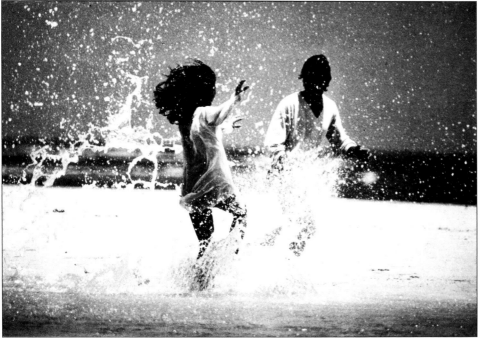

Depth of field is important in the tranquil park scene above. The photographer wanted to show everything in sharp detail from the dappled foreground to the distant background figures. Aperture priority metering suits this type of scene.

Movement and timing are the crucial elements of the shot on the left. A fast shutter speed, and a quick response, have caught the flying spray and sense of fun perfectly. A shutter priority camera enabled the photographer to set the speed and then concentrate on the action.

Manual and automatic/2

When can you trust your camera meter, and when should you override it? If scenes with an average distribution of tones are lit from the front or the side, the camera's meter will probably serve well enough. But if the light is coming from behind the subject, for example, the meter may give a reading for the bright background so that the subject itself is underexposed and appears as a silhouette. Exposure often involves a creative decision and the meter's reading should be seen as a starting point. Identify the part of the scene you consider the main subject of the picture. If this is much lighter or darker than the rest, you should adjust the exposure to show good detail there, rather than accepting an average of the whole scene.

An effective way of basing exposure on the most important area is to take a "key reading" close to the main subject before moving back to your shooting position. You can do this readily with manual exposure controls but need some other method with automatic systems unless there is a so-called memory lock, which allows you to set the exposure and then hold it while you move to another camera position. Other automatic cameras have a compensation dial, which allows you to choose up to two stops more or less exposure than the automatically measured average of the scene.

Mixed light and dark areas in the same shot require care. If you think a light background such as the sky is biasing the meter, compensate by giving one or two stops extra exposure. Conversely, if you have a small, light subject against a dark background, give slightly less exposure than is indicated in case the meter is reading the background. For scenes with important detail in both light and dark areas, take readings for each and pick the midway setting. Averaging, as it is called, is useful for scenes with interesting skies or mixed sun and shade.

When you are in doubt, "bracketing" offers a solution. Take the same shot three or five times, changing the exposure in either one- or half-stop increments around the setting you think is correct.

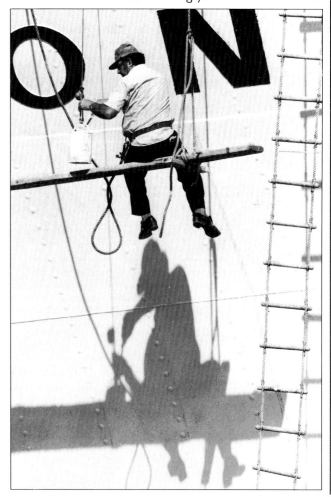

Exposure compensation
Automatic cameras often have a dial for exposure adjustment. A light subject (right) may appear dull at the automatic exposure, but plus one stop on the dial restores the true brightness (far right).

Reading from a face

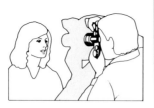

1 – When you need to set the exposure for an important element such as a face, move close so that the face fills the whole frame, and set the exposure.

2 – Then move back to your chosen camera position and take the shot at the same setting. Some automatic cameras have a memory lock to help you do this.

Bracketing is advisable when you are unsure of a reading. The meter alone could not determine the right balance in the scene below. The photographer made five varying exposures and selected the third frame as the best for enlargement.

1

2

3

4

5

Where should the light be?

Once you understand the fundamentals of setting exposure, you can forget the old rule about shooting with the sun behind the camera or over your shoulder. Although you should avoid strong light flaring directly into the lens, you can vary the camera's viewpoint in relation to the light, and achieve remarkable changes in appearance and mood of your pictures as a result.

The main thing is to try to choose the direction and quality of light that best suit the subject. If you are taking a portrait, for example, select an angle of light that allows the subject to look comfortably toward the camera, rather than squinting as the girl below right is doing. Move around and study the way shadows fall differently as your viewpoint changes. And notice how the light models a subject to convey a sense of form – the three-dimensional aspect of things.

Frontlighting – light behind the camera – brings out good details and colour but tends to flatten form unless the light is soft. Side or oblique lighting is better for subjects with interesting textures – tree bark, for instance – or when you want to define features sharply, such as waves, rocks, or even a craggy face. Backlighting – light behind a subject – tends to conceal form altogether, especially if you expose for the background, turning the subject into a silhouette. The three landscapes on the opposite page show some of the transformations you can anticipate as the sun moves across the sky.

Strong sunlight forces the girl to shield her face with her hand (right) and screw up her eyes. Heavy shadows make her cheeks look gaunt. If you have to take shots of people in strong sun, try to avoid placing them so that they face into the full glare.

Using shade
You can take advantage of the soft light provided by the shade of an umbrella, building or tree when taking portraits. But remember to read the exposure directly from the face in case a bright or dark background fools the exposure meter.

Open shade offers far more flattering lighting (right). Here the light is even and diffused, softly modelling the girl's face and allowing her to relax her features and open her eyes. For this reason, an overcast day or soft evening light is good for portraiture.

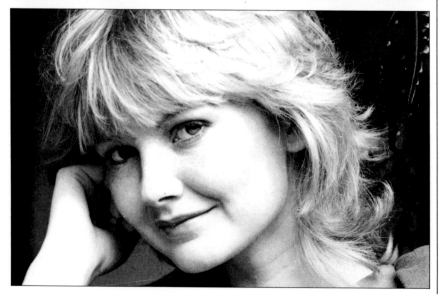

Hard sidelighting from a bright morning sun casts long shadows and creates extreme contrast between the highlights and dense, featureless areas. The light shows up the knobbly texture of the ground and gives a powerful impression of the rugged terrain.

Nearly overhead sun in a hazy sky illuminates the top surfaces of the rocks, casting shorter and softer shadows. The broad light, diffused by the haze, gives strong modelling, revealing greater form and detail.

Backlit by a low sun, the horizon is etched against the evening sky. Detail is lost in all but the foreground crag, and shapes appear in delicate silhouette. The effect of the photograph is much more two-dimensional.

Handling limited light

Low light produces some of the most evocative and spectacular photographs you can take – from sunsets and dimly lit interiors to street scenes at night with illuminated signs and floodlit buildings. In order to use limited lighting effectively, you need first of all to escape from the idea that the only acceptable image is one that is evenly and brightly lit. At night or in a dark interior, for example, there is often too little light or too much contrast between highlights and shadows to obtain full detail over the whole image. Make a virtue of necessity, and take advantage of the way low light simplifies an image. You may be able to create a strong silhouette or take a shot in which the light forms an interesting rim around the subject. A good time to experiment is at dusk, when there is still enough light for a relatively short exposure, but street and house lights evoke a nocturnal mood.

To obtain enough light for exposure in low lighting situations, you often need to use both wide apertures and slow shutter speeds. You can shoot some subjects with a handheld camera if you have fast film and a lens with a wide maximum aperture – at least f/2.8. But many subjects demand a slow exposure, requiring a tripod or other form of camera support. When using a wide-angle or normal 50mm lens, support the camera for exposures slower than 1/60; with a long lens, 1/125 is about the slowest safe speed for handheld shots. One great advantage of a tripod and a long exposure is that you can use a very small aperture and so increase the overall sharpness of your image. However, very long exposures in dim light can produce unpredictable effects, especially with colour film, so you may need to try several different exposures to get the picture right.

Low light exposure guide
Exposure readings tend to be misleading in low light, but you can use this chart for typical subjects as a rough guide.

FILM IN USE	ISO 100		ISO 400	
Brightly lit shop windows	1/30	f/2.8	1/60	f/4
Well-lit street scenes	1/30	f/2	1/60	f/2.8
Fireworks	1/8	f/2.8	1/30	f/4
Floodlit buildings	2 secs	f/5.6	1/2	f/5.6
Street lights	1/4	f/2	1/15	f/2
Neon signs	1/30	f/4	1/125	f/4
Dim church interior	10 secs	f/4	$2\frac{1}{2}$ secs	f/4
Landscape at full moon	20 secs	f/2.8	5 secs	f/2.8

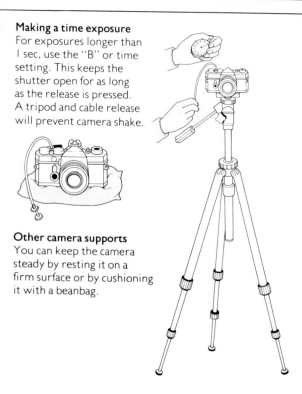

Making a time exposure
For exposures longer than I sec, use the "B" or time setting. This keeps the shutter open for as long as the release is pressed. A tripod and cable release will prevent camera shake.

Other camera supports
You can keep the camera steady by resting it on a firm surface or by cushioning it with a beanbag.

Snaking streaks of light
(left) were created by a time
exposure that recorded the
head and tail lights of cars
moving across the bridge.
The evening sky provided
the meter reading to show
the bridge in silhouette.

Delicate rimlighting traces
the monk's profile to produce
a powerful portrait – the
photographer metered the light
on the monk's forehead, and
gave one stop more exposure.

Shimmering water reflects
light from the evening sun,
backlighting the figures and
foreground. To reduce the
foreground to silhouettes, the
photographer metered the
bright area of water.

Using flash/1

The most portable and convenient means of providing extra light for photography is an electronic flash unit. At its simplest, the unit is about the size of a large matchbox, and has a gas-filled glass tube set in a reflector at the front. Sliding the unit into an accessory slot – known as the hot shoe – on top of the camera completes a circuit. And when you release the shutter, the circuit discharges a high voltage current between two electrodes in the tube, giving a brief, intense flash of light.

The speed of the flash – at least 1/500, and often much faster – is what really determines the length of the exposure. You need to adjust the shutter speed only to ensure that when the flash fires the entire frame is exposed. This usually means setting the shutter at 1/60 or slower to be sure that it is open fully when the flash fires. Because individual flash units vary in light output, they have a chart or dial showing which aperture to set on the lens and how far the light will reach. As explained below, sometimes you have a choice of apertures. On the simplest manual units you may need a different aperture for each different camera-to-subject distance. Some units automatically synchronize light output, aperture and shutter speed.

Between flashes, the unit recycles by drawing power from batteries and converting this to the high voltage capacitor charge needed to produce the next flash. As soon as the cycle of charging is finished – usually within five to ten seconds – a neon "ready" light comes on, indicating that there is enough power stored for another flash.

Power control

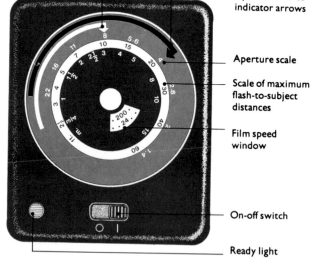

Aperture choice indicator arrows

Aperture scale

Scale of maximum flash-to-subject distances

Film speed window

On-off switch

Ready light

Using on-camera flash
The on-camera flash unit above has a calculator dial (enlarged above right) on its top surface. As an example, the dial has been set to show which f-stops you may choose if you are using ISO 200 film. You have a choice of f/4 or f/8 – the white and black arrows point to these f-numbers, and the maximum working distances appear alongside. In the operating sequence explained at the right, you select the correct power output with a switch elsewhere on the unit – again marked in white and black to correspond with the chosen aperture.

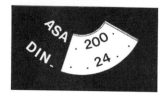

1 – Turn the calculator dial until the speed of the film in use appears in the window.

2 – Slide the foot of the flash unit into the camera's hot shoe.

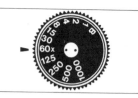

3 – Set the shutter speed to 1/60 – sometimes marked with X or a lightning bolt.

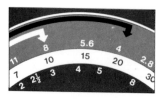

4 – Gauge the distance to the subject. Then choose the f-stop – here f/4 for 20 feet.

5 – Slide power control to the setting that corresponds with the aperture chosen.

6 – Switch on flash unit. You can take pictures soon after the ready light glows.

Simple electronic flash
Units such as the one at left are small enough to drop into a pocket, but can light subjects well only up to about 10 feet away.

Dedicated flash
The more powerful unit below left is matched – or dedicated – to a particular camera to reduce manual work. The reflector can tilt up to spread light.

High-power flash
The large unit at right has to be attached to the camera by means of a bracket. Two flash tubes give a greater output of light for difficult subjects and a cable connects the flash to the camera.

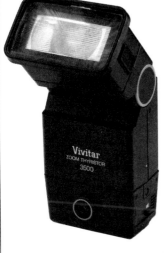

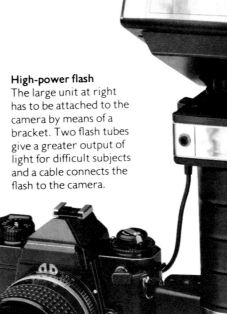

Random action – *such as at a party – is a natural choice for a flash picture. The brief burst of light freezes all motion, and lights up only those parts of the subject closest to the camera, so that they stand out against a black background.*

Using flash/2

An electronic flash unit is a highly useful source of light, but perched on top of the camera, pointing directly forward, much of its potential may be wasted. Pictures taken with the flash in the accessory shoe can look harsh and unnatural – portraits may appear unflattering, because flash, when it is aimed directly in line with the camera, seems to flatten the subject's features.

There are two ways of getting around this problem. The simplest is to move the flash off the accessory shoe, and hold it above or to one side of the camera. Most flash units have a short cable – called a flash cord – to make removal possible. The cord plugs into a small socket on the camera body, establishing an electrical connection so that the flash still fires at the moment of exposure.

In practice, the cord is often short, and you may have to buy an inexpensive extension cord, so that you can hold the flash at arm's length. To provide modelling illumination. point the flash straight toward the subject, but at an angle from the camera. It is easier to do this if you can get someone to hold the flash for you.

The other way to improve flash pictures is to bounce the light off a reflective surface such as a white-painted wall or ceiling. This method is more complicated than simply removing the flash from the camera, but it produces very soft, diffuse lighting that looks remarkably natural.

For correct exposure with bounce flash, you need a modern type of flash unit with a tilting reflector, and a photoelectric cell to measure and regulate the power of the flash automatically. When you tilt the reflector to point at the ceiling, this electric eye continues to point at the subject, and ensures that the unit provides enough power to compensate for light lost over the extra distance the light has to travel to the subject via the ceiling. Such a flash unit usually gives you several choices of aperture and you should always choose the widest aperture option for bounce flash. Used in this mode, the flash unit is operating at the limits of its power reserves, and choosing a small aperture may lead to underexposure. There is likewise a danger of underexposure with bounce flash – it is impractical in rooms with very high or dark-coloured ceilings.

Flash is useful not only in dark places but also in broad daylight. When the sun is very bright, the contrast between shadows and highlights may be excessive, so that the shadows look dark and murky. With a flash unit, you can fill in dark shadows with light, and brighten up the colours of the picture. Setting the exposure for fill-in flash is not quite as straightforward as for regular flash – the box on the opposite page explains how to do it.

Sparkling highlights give this impromptu portrait a party atmosphere. By taking the flash unit off the camera, the photographer was able to move the shadows to one side, and avoid the flat lighting that flash can produce when mounted on the camera.

Flash off the camera
Hold the flash at arm's length, and point it toward the subject. You need a long flash cord, and it helps if you have someone to hold the flash for you at an appropriate angle.

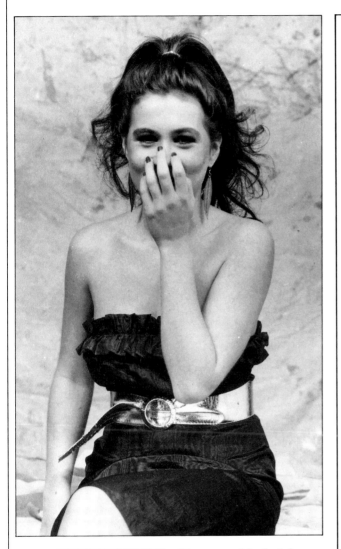

The natural look of the portrait above comes not from daylight but from bounce flash. With the flash unit pointed at the ceiling, the light reaching the subject is diffused, soft and even – perfect for portraits.

Bouncing flash

Choose the widest aperture the flash unit allows, and tilt the unit's head upward. This works best when the subject is close, and the ceiling or reflective surface is low and white.

Fill-in flash

Bright sunlight, seemingly ideal for photography, can be very harsh – and particularly unflattering for portraits. When the sun is overhead or behind the subject, shadows can look empty and black.

An electronic flash unit can put light back into the shadows, as the pictures below show. But to retain the look of the natural light, you should reduce the flash power to about half its normal value.

You do this by "tricking" the flash into acting as though your film is more sensitive than it really is. On the unit's calculator dial, change the film speed setting so that it reads double the speed of the film you are using. This will give you a choice of smaller apertures. Pick the smallest and set this on the lens. (Simple units may not offer a choice.)

If you now take a meter reading, you may find that you can use the synchronized shutter speed, or slower, and still provide a correct natural light exposure. Finally, reduce the aperture by half a stop to adjust to the extra light from the flash.

Without flash

With fill-in flash

STEPS TO BETTER PICTURES

Once you have mastered the basic practical control of your camera, you can concentrate on the creative techniques that lead to strong and interesting pictures. You may want also to explore the effects of changing lenses, or using filters to control colour and reflections. Adding to your equipment can improve results dramatically – a telephoto lens that lets you fill the frame with a single face really does add impact to a portrait, for example, and a wide-angle lens can enable you to take pictures that seem impossible. Extra lenses also introduce exciting opportunities for experiment – one of the great delights of photography is its ability to show us familiar objects in a new way. But sophisticated equipment is not enough. Learning how to exploit viewpoint, framing and timing, how to handle backgrounds, emphasize colours and shapes, portray movement or catch a split-second event – these are the techniques at the heart of successful picture-taking. Most of all, a photographer has to learn to select – a close-up of a flower can say more than a whole field of blooms. "Less is more" is a first principle of creative photography.

Closing in on the subject becomes possible with a telephoto lens – just one of the ways of extending your creative range. To represent graphically the effect of zeroing in, the photographer of the sailboat took his picture off the special focusing screen of a large-format camera that was focused on the boat. The concentric rings are engraved on the screen to assist focusing.

Viewpoint

One of the simplest ways of achieving better pictures is to learn where to stand in relation to your subject and at what level or angle you should position the camera. Walk around looking at the subject through the viewfinder from different positions and angles. Think about whether you could improve the picture by moving closer, or standing farther back, or shooting from a low or high viewpoint. Simply moving the viewpoint in one of these ways can make the difference between a mundane picture and one that is truly striking.

Usually when you are photographing people, you should keep the camera level and point it directly at the subject. Even so, you should try different camera positions — to concentrate attention by moving in close, for example, or to include more of the surroundings by moving back. The choice may depend on whether you want to cut out a distracting background by moving in, or to add an interesting foreground with a longer view. Willingness to experiment will reveal many possibilities beyond the straightforward head-and-shoulders shot. Dramatically high or low viewpoints, or positions very close to the subject's face may just create ugly distortions. But provided the distortion is calculated, rather than an unwanted side-effect, there is no reason why you cannot succeed with an unusual approach.

With other subjects, your approach can be even freer. Buildings often look stunning when photographed from below, with the camera tilted steeply upward, and you can often bring out the pattern of city streets by shooting directly downward from a tall building. An ordinary tree could be intriguing seen from so close that only bark and a few leaves are in the frame. Whatever your subject and your intentions, try all the possibilities you can think of — and then look for more.

Classical columns tower over a low camera viewpoint. They make an imposing frame for the steel and glass grid of a modern building.

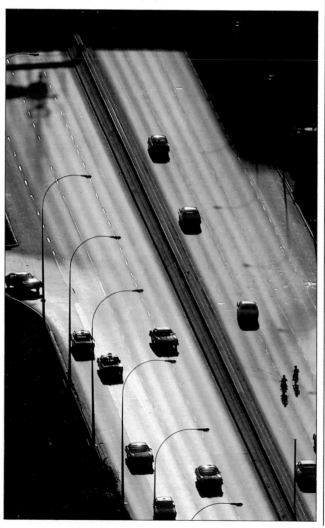

A highway from above becomes a dramatic diagonal composition of light and dark in the late afternoon sun. By using the vantage point of a high building and a downward camera angle, the photographer has found an image more exciting than the conventional city panorama would provide.

The sunbather could have been photographed from several different angles, and all of them would have been more obvious than the one chosen – standing directly over her and looking down. This was also the most effective, with blue water, white diving board, red wine, and tanned skin arranged in a striking composition.

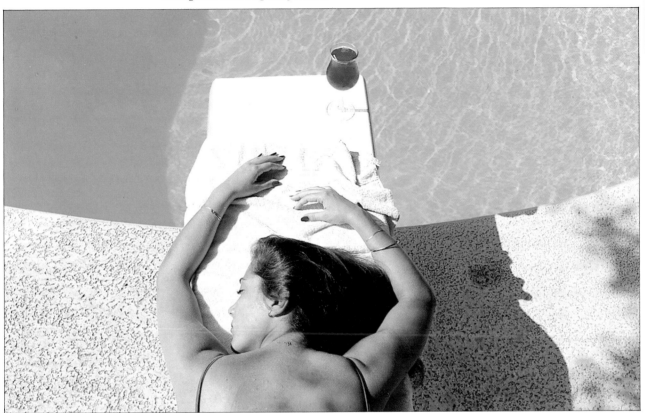

A boy fixing his car grins at the photographer, who has joined him right down at ground level to make a charming, informal portrait. Inventive approaches such as this can produce outstanding shots, full of spontaneity and life. Technically, the shot is simplicity itself – using a standard lens on a 35mm camera in daylight.

How lenses control the image

In its ability to capture and focus the image of a subject on film, the lens is the most important part of the camera. The size and appearance of the image can vary greatly according to the type of lens you are using. And as all 35mm SLRs can be fitted with interchangeable lenses, photographers need to understand some basic lens characteristics.

How much of the scene a lens can capture depends on its angle of view – the way it sees the subject in front of the camera. This is determined by the focal length of the lens – in simple terms the distance from the optical centre of the lens to the film plane when focus is set to infinity. Focal length is marked on the front of the lens in millimetres, and this is how lenses are normally described – as 28mm, 50mm or 135mm lenses, for example. Most lenses are within a range from 18mm to about 600mm, although shorter and longer focal lengths can be obtained for more specialized purposes.

Lenses with short focal lengths can convey to the film more of a scene than the eye itself can see when looking through a frame the same size as the viewfinder. They do this by sharply bending the light passing through them, making each object in the scene appear smaller than the eye would see it and, by means of this optical shrinkage, fitting more objects into the frame. For this reason, lenses of short focal length are called wide-angle lenses. The most extreme of them is the so-called fisheye lens, which produces bizarre distortions by compressing an exceptionally wide view onto the relatively small format of the film. At the other end of the scale, telephoto lenses – with long focal lengths – bend the light from the subject relatively little, and produce an enlarged image of a small part of the view, as does a telescope.

From a single camera position, you can thus produce completely different views of the subject by

1 – A 28mm wide-angle lens takes in a broad view of the subject, but makes the distant buildings appear smaller than they would to the eye. This view of the Manhattan skyline from Liberty Island includes a large expanse of the stormy sky that loomed over the city when the shot was taken – and links near and far elements of the scene. But New York's famous skyline looks relatively insignificant.

2 – A 50mm normal lens renders the scene more as the eye would see it. The photographer aimed higher to keep in much of the sky but exclude the foreground. The lens helps to emphasize the city skyline, and the view is relatively wide.

using different lenses. With a wide-angle lens, a human figure can be shown as part of an extensive landscape, or you can close in on the face alone with a telephoto lens. The enormous flexibility gained by having interchangeable lenses is one of the great advantages of the 35mm SLR camera. On the other hand, individual lenses are expensive and also heavy to carry around. One solution is the zoom lens, which has a variable focal length, allowing you to achieve a range of framings and subject enlargements with a single lens. But be careful; good quality zooms are very expensive and they always have smaller maximum apertures than do equivalent lenses of fixed focal length. Zoom lenses are also heavier than lenses of fixed focal length because of their complex construction, and so may be more difficult to handle. The six pages that follow introduce the major types of lenses and the creative uses to which they can be put.

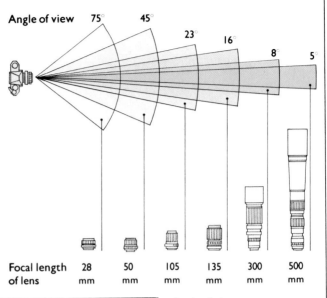

| Angle of view | 75° | 45° | 23° | 16° | 8° | 5° |
| Focal length of lens | 28 mm | 50 mm | 105 mm | 135 mm | 300 mm | 500 mm |

Angle of view
The lenses shown above with their angles of view are those most commonly used with 35mm SLRs. Note that the lens with the widest angle of view requires only a short body. Longer lenses can reach out farther to close in on (and enlarge) distant details. But as the focal length increases, the extent of the view decreases both in width and in height. Cameras with film formats larger than 35mm require lenses of longer focal length to achieve the same results, because more enlargement is needed to cover the larger area of the film itself.

3 – A 135mm telephoto lens brings forward the buildings in the same scene, making the twin towers of the World Trade Center the dominant subject. The sky now takes up a much smaller part of the frame, and the skyline is reduced in width.

The size we see

The 35mm SLR camera comes fitted with a 50mm lens (or sometimes 55mm) – the so-called normal lens. Many photographers never use any other lens, and still take perfectly good pictures.

The most striking feature of the image produced by a normal lens is the naturalness of its perspective. Because wide-angle lenses take in a broad view of the subject, they actually appear to reduce the scale of distant objects in relation to those in the foreground, thus exaggerating the perspective effect by which objects appear smaller the farther away they are. Telephoto lenses have the reverse effect, appearing to compress objects together despite the distance between them. The normal lens, on the other hand, reproduces the scene with its perspective much as the eye sees it. In a sense, photography is most objective with a normal lens – the camera shows the world essentially as we see it.

Because normal lenses are produced in large quantities, they are relatively cheap. They are also extremely versatile. They are suitable for near and distant subjects, accurately focusing subjects at a considerable distance and within two feet of the lens. And they can be used in low light – or with fast shutter speeds in action shots – because they have wide maximum apertures: f/l.8 is common and f/l.4 is not unusual. Taking good pictures with normal lenses needs skill, however. As there is no strong special photographic feature such as dramatic magnification to compensate for poor composition, the image can easily appear bland. More than with any other lens, you must frame the picture accurately and compose it carefully.

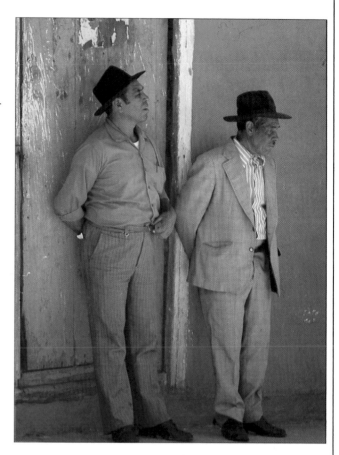

Street portraits *look more natural when taken with a normal lens – the distortion-free images it forms closely resemble the world as seen with our eyes.*

The normal lens
The photographer's work-horse, the 50mm or 55mm lens can give good definition, even in failing light.

A red bicycle, the same shade as the nearby door, establishes a simple but vibrant pattern of line and colour. For uncomplicated compositions such as this, the normal lens is ideal.

A tanned back says "summer sun" more eloquently than might a traditional beach scene. The close-focusing capability of the normal lens allowed the photographer to frame the image tightly and eliminate surrounding clutter.

Widening the view

Although a normal lens shows natural perspective, you need a lens of much shorter focal length to get breadth of view. The view of a normal lens is restricted to a viewing angle of about 45°, and to overcome this restriction, you need a lens that can fit more into the same frame – a wide-angle lens. With a standard SLR camera, any focal length shorter than about 35mm gives a wide-angle view, although the effects become really noticeable only at 28mm or shorter: many photographers use 35mm lenses in place of a normal lens. Focal lengths shorter than 24mm are available. But while compressing such a broad field of view onto the film format, very wide-angle lenses create distortion, and the more extreme of them are best considered as interesting special-effects devices. Distortion will be most obvious with scenes involving straight lines, as in architectural photographs.

The most obvious practical use of a wide-angle lens is for pictures in which interesting details cover a wide angle in relation to where you are standing. If you want to show most of your living room in one photograph, for example, your eyes, with an angle of view approaching 160° from left to right, may see the whole room. But it may be impossible to move back far enough to fit everything into the viewfinder frame. A wide-angle lens will help by reducing the image of the objects in the room and squeezing more of them onto the film. In the same way, a wide-angle lens allows you to frame an exterior scene

Sweeping perspectives and an impressive sense of space give a dramatic look to landscapes shot with a wide-angle lens. Taking advantage of the distortion inherent in a 20mm lens, the photographer of the desert road on the left has turned his picture into a striking landscape, with the road itself forming a shape of startling impact.

Cramped space makes it impossible to move back far enough to show a subject like this adequately without a wide-angle lens. The 35mm lens used here was wide enough to allow the photographer to close in on a furniture restorer and the instrument he is polishing, yet still show his surroundings.

Framed by an arch, and shaded by citrus trees, these Portuguese women make a fascinating folk tableau for the camera. By composing the picture in order to exploit the wide angle of view and great depth of field of the 28mm lens he was using, the photographer was able to include much of the surroundings, and to identify the location as a quiet courtyard. A normal lens would have shown only the group, losing much of the intimacy of this image.

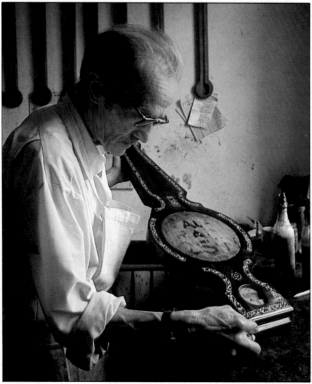

effectively with foreground objects near the frame edges, as in the shot here taken through an archway. The result is often to draw the viewer into the picture, creating a feeling of involvement that can give photographs taken with a wide-angle lens a strong sense of immediacy.

As a most useful side-effect, lenses of short focal length produce greater depth of field than do normal lenses at the same aperture. This makes them very useful in poor light and in situations where there is little time to make fine adjustments to the focus. When you are photographing general street scenes, for example, a wide-angle lens will let you point the camera and shoot without delaying to adjust the focusing ring.

Wide-angle lenses
These three lenses, which have focal lengths of 24mm, 28mm and 35mm, outwardly resemble normal lenses. But the likeness ends as soon as you fit one to your camera and look through the viewfinder. Cramped views expand, and at small apertures the depth of field makes focusing less critical.

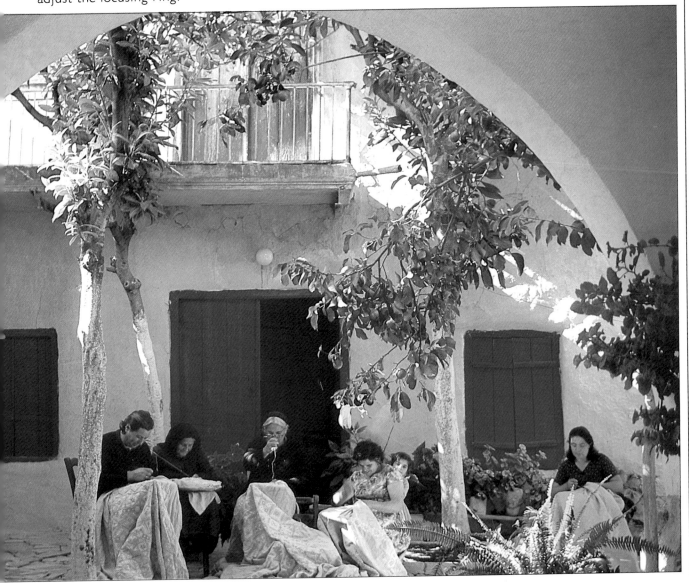

Concentrating the view

Distant subjects that look good in the viewfinder often seem disappointing in the final print, because the attractive details that initially caught the eye occupy only a small area in the middle of the frame. Moving closer is sometimes the answer, but if you are photographing a football game, for example, you cannot intrude on to the playing area. The solution is to use a telephoto lens. This has an effect opposite to that of a wide-angle lens – instead of taking in a wider field of view than a normal lens, it records a much smaller area, and magnifies the subject.

The degree of magnification depends on the focal length of the lens. A 100mm telephoto has a focal length double that of a normal lens, so it doubles the scale at which the eye would perceive a subject. At the same time, the lens's horizontal field of view is half as wide as that of a standard lens.

The most popular telephotos have focal lengths of between 85 and 250mm. The longer focal lengths, although powerful, are much more difficult to handle and to focus. Those of 400mm and longer can pick out subject details missed by the naked eye but require tripod support.

Besides their magnifying effect, all telephoto lenses have several other common characteristics. The most dramatic of these is the compression of distance that they appear to cause. If you look at a row of objects of equal height and equally spaced – such as telegraph poles – receding into the distance, you will notice that the distant ones seem more tightly packed. When you photograph this scene with a telephoto lens, only the distant poles are included in the frame, and so the picture appears flattened out with its different planes packed together. For example, in the shot of the Grand Canyon on the opposite page, a scene that stretches away from the camera for several miles has been foreshortened startlingly, because a long lens has eliminated the foreground.

Another important characteristic of a telephoto lens is that it gives less depth of field than does a normal lens. As a result, when the lens is focused on a nearby object, the background is unsharp – a useful way of concentrating attention on the principal area of interest. Portraiture with telephoto lenses is often effective for this reason – and also because you do not need to crowd your subject to get a detailed head-and-shoulders shot.

Telephoto lenses

Telephoto lenses magnify the image, filling the frame with a subject that may look like an insignificant detail when seen through a normal lens. These three lenses have focal lengths of 135mm, 200mm and 400mm, magnifying the image 2.7, 4 and 8 times respectively.

400mm 200mm 135mm

Pleasing portraits are easier with a telephoto – its shallow depth of field puts background distractions out of focus. At the same time, magnification of the image allows you to move back to a more comfortable working distance, thus eliminating perspective distortions.

The majesty of landscape is often missing from pictures taken with a normal lens. A telephoto can restore the sense of scale and drama – as in the picture here of the Grand Canyon, taken with a 200mm lens.

The thick of the action at a sports event usually can be captured effectively only with a telephoto lens. The photographer of the football game opposite used a 400mm lens to get close to a player weaving through tacklers on the far side of the field.

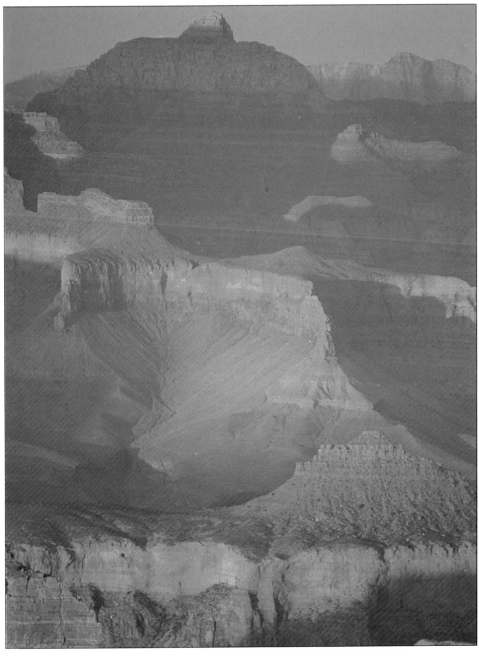

Recording everything sharply

More often than not you will want your entire image to be sharp from foreground to background – to give a figure a sense of location, for example, to link foreground and background elements, or merely to record the whole of a view. The simplest way to maximize depth of field is to stop down the lens. Stopping down means reducing the aperture of the lens, and the smaller the aperture you use, the greater the depth of field in your photograph. Stopped down to f/16, for example, a normal lens focused on a subject 15 feet away will record sharply everything beyond about eight feet, whereas with the aperture widened to f/2, only the subject itself will be sharply focused, the background and foreground appearing blurred.

Stopping down the lens requires that you also slow the shutter speed to give sufficient exposure. Unless the light is bright, this may limit your freedom to choose an aperture small enough to gain the depth of field you want. Fast film can help or, if the subject is static, you may be able to shoot at a slow shutter speed with the camera steadied – preferably on a tripod. To check how much of your picture will be sharp at a given aperture, you can either refer to the depth of field scale on the lens (see below left) or use the preview button. This closes the lens down to the f-stop you have chosen, allowing you to see through the viewfinder the zone of sharp focus in your image.

Two other factors control the extent to which you can record the whole picture sharply – the lens you use and the camera-to-subject distance. The shorter the focal length of your lens the greater the depth of field. Thus a wide-angle lens has advantages if you want the greatest near-to-far sharpness. Finally, you can extend sharpness by moving back from your subject, since depth of field increases with the distance between the camera and the subject.

Using the depth of field scale

A typical lens (below) has a focusing distance scale linked by engraved lines to pairs of f-numbers on a depth of field scale. From a chosen f-number, the left-hand line indicates the distance to the nearest point in sharp focus and the right-hand line indicates the farthest point.

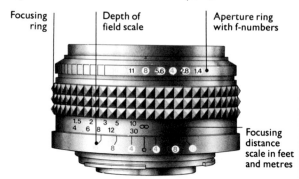

Focusing ring | **Depth of field scale** | **Aperture ring with f-numbers**

Focusing distance scale in feet and metres

Above, the lens is focused on infinity (marked with a ∞ symbol on the distance scale) and the aperture set at f/8. The line from the "8" on the left points to 16 feet, showing that focus is sharp only beyond about 5 metres. The "8" line on the right, which is well beyond the infinity symbol, indicates that there is depth of field to spare.

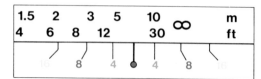

By turning the focusing ring to the right so that the ∞ symbol aligns with the "8" line on the right, infinity is still in focus. But depth of field now extends down to 10 feet, so more of the foreground is in focus.

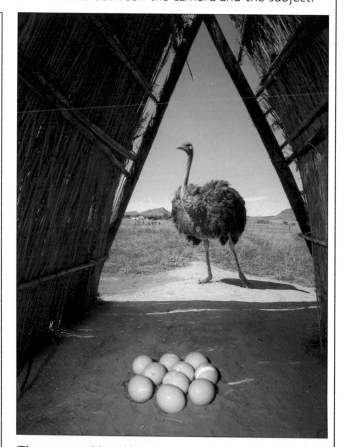

The maternal bond between an ostrich and her eggs makes a striking composition. Focusing on the midground ensured that both were sharp despite the distance dividing them.

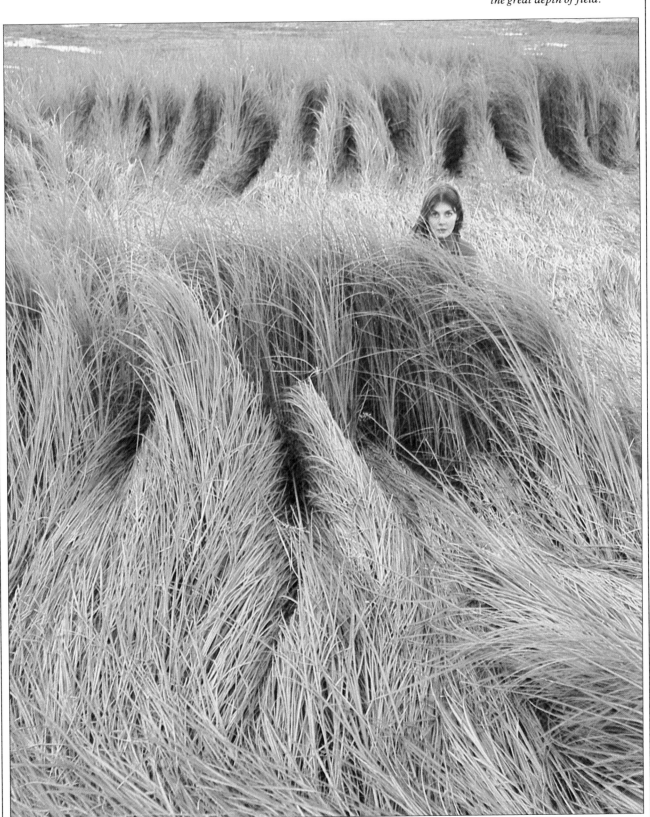

Isolating what is important

In photography, you often need to take special measures to focus attention on one centre of interest – usually because there are distracting elements in front of or behind your main subject, and you may not be able to get near enough to your subject to cut out the unwanted details. When you are taking a candid portrait, for example, bright colours or strong shapes in the background or foreground may compete for attention with your chosen subject. In such circumstances the best way to simplify the image is to put intrusive elements out of focus by deliberately creating a shallow depth of field. Colours are toned down and shapes reduced to an unobtrusive blur when they are out of focus.

There are three ways of minimizing depth of field: using a wide aperture, a long-focus lens or a close viewpoint. Just as you can stop down the lens to achieve maximum depth of field (overleaf), so you can deliberately open up the lens and choose the widest aperture possible to take advantage of the restricted focus it offers. Of course, using a wide aperture makes it crucial that you focus accurately on the part of the scene you want to be sharp, as any slight error will be noticeable. Because long-focus lenses have more limited depth of field than normal lenses, they are well suited for selective focusing, especially when set at a wide aperture. Finally, if the light is too bright for a very wide aperture to be feasible, remember that you can also throw a background out of focus by moving in close to your subject – depth of field is shallower in close-ups than at average focusing distances.

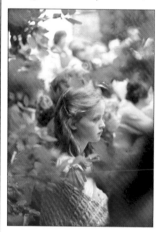

A face in a crowd can be made to stand out. Here, the photographer focused carefully on the girl, then opened up the lens to blur the foreground leaves and soften the background. The blurred elements serve both to emphasize the sharply focused face and to frame it.

Zoo portraits are often spoiled by cage bars and wire netting. Here, however, the photographer concentrated attention on the main subject by holding the camera close to the cage and using a wide aperture to cut depth of field. This throws the bars and netting so out of focus that they are almost imperceptible.

A girl balancing on the bar
of her sports bicycle totally
dominates the picture here,
because a long-focus lens set
at a wide aperture has been
used in order to soften the
intrusive colours and shapes
in the busy street behind her.
Shooting with a long-focus
lens is also a simple way of
filling the frame with your
main subject without having
to get too close.

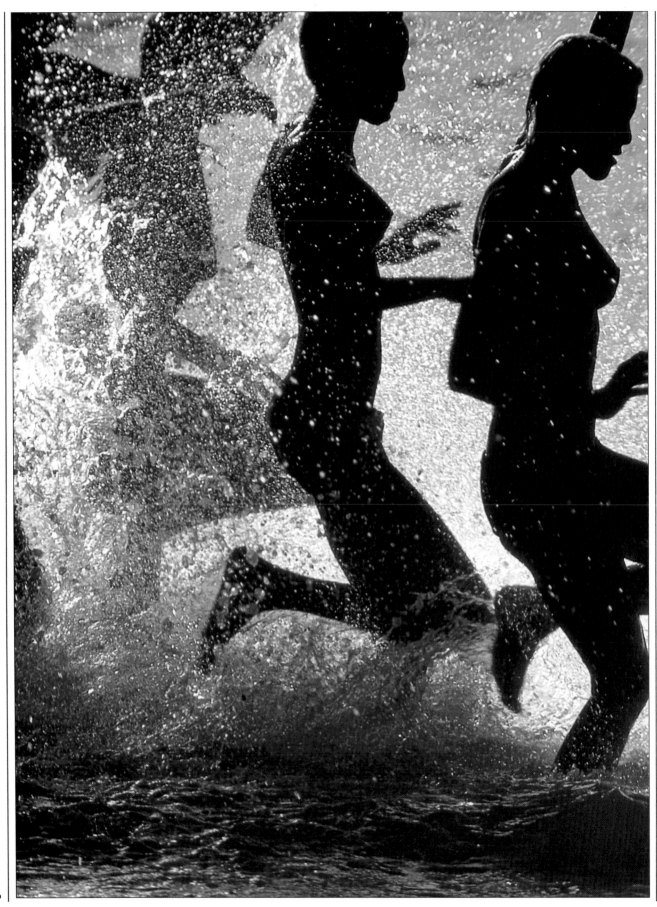

Moving subjects/1

The camera's ability to capture a permanent image of momentary events and moving objects is one of the most persuasive charms of photography. The shutter makes this possible: its fastest speeds enable you to halt a thundering express train, or transfix in mid-air a child on a swing. Often, however, lighting conditions oblige you to use shutter speeds slower than the ideal for stopping action. In these circumstances you need to know how slow a speed you can safely use without the subject appearing as a formless blur. The choice you make may depend on several factors.

An obvious consideration is how fast the subject is moving; but much more important is the rate at which the subject's image is passing across the film. This depends on distance and direction. When the subject is far off, or is either approaching you head-on or going away from you, the image is changing its position more slowly on the film than when the subject is nearby and crossing the frame. You can therefore use a slower shutter speed if you want to freeze the movement of distant, approaching or receding subjects.

Composing the picture so that distance and direction are working for you is one way to make maximum use of the camera's action-stopping power. Another trick is to exploit natural pauses in otherwise rapid movements. Many moving subjects actually reach equilibrium for brief instants: a pole-vaulter, for example, is almost static for a moment before dropping over the bar. By anticipating this peak in the action, you can give the illusion of freezing fast movement even when you are obliged to use a slow shutter speed. The picture on this page of a girl on a swing was taken in just this way: the photographer waited until she was almost motionless in the air, then pressed the shutter.

To capture the excitement of a splash in the surf, the photographer set a fast shutter speed of 1/1000 sec. Not only has this frozen the girls' flailing legs; it has even recorded the water as a shimmering cascade of crystal drops.

Swinging high in the air, this little girl reaches an instant of equilibrium at the end of each arc. At these moments, even quite slow shutter speeds can produce crisp images that seem to sum up the rapid movement in between.

Shutter speeds to freeze movement
The chart at the right indicates the shutter speeds needed to stop movement in a range of subjects at progressively greater distances from the camera. The walker could be stopped at 1/125 from nearby, but the cyclist would need to be 30 yards away and the car and train even farther. For safety, shoot fast if a subject is crossing the frame.

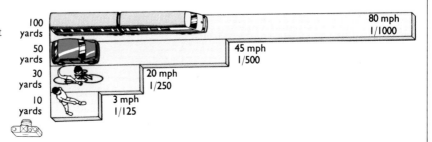

Moving subjects/2

In recording a crisp, sharp image of a moving subject, a fast shutter speed may fail to give a true impression of motion. Setting a shutter speed that is too slow to freeze all movement results in an image that is slightly blurred. But this image may come much closer to the way we perceive speed — as a continuous flow of motion. In the pictures here, for example, whirling or blurred lines give a vivid sense of movement. Such pictures often work best if only part of the subject is blurred while the rest of the image is sharp and clear in the normal way. The trick is to choose a shutter speed that will give enough blur to suggest motion yet not so much that the subject is unrecognizable. This is easiest when elements of the subject move at different speeds, as in the shot below of the galloping horse, where the pounding hooves are blurred although the horse's head and body retain their shapes.

A less obvious but highly effective way of suggesting movement is to move the camera itself so that static parts of the subject are blurred, just as they appear when we are moving ourselves. The streaks behind the ski jumper on the opposite page were produced by the camera technique known as panning. With the shutter set to a slow speed of 1/60, the photographer simply pivoted his body so as to keep the moving subject in the centre of the frame throughout the exposure. The panning blurs the background (or foreground) but keeps the subject sharp and clear. You will need some practice to select the optimum shutter speed (1/30 to 1/125 is generally a sensible choice for most subjects) and also to achieve a smooth pan with the subject centred. You should try to choose a subject lighter in colour or tone than the background against which it is moving.

A ski jumper flashes past, and by panning the camera with him the photographer has caught perfectly the tension and concentration on his face and the relaxed balance of his body. At the same time, panning has moved streaks of light through the trees in the background, conveying something of the speed and excitement of the dizzying flight.

Animal energy seems to flow from the image of a galloping Arab stallion. A fast shutter speed could have defined the horse more clearly but would probably have given a less vivid sensation of motion than does this impressionistic picture. The camera was panned at 1/60 to keep pace with the horse but not with its flying hooves.

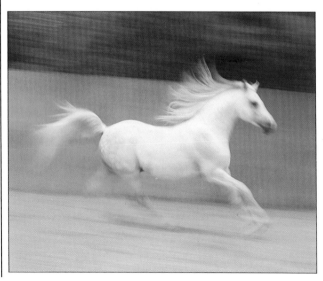

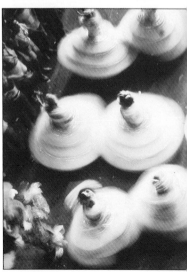

Like spinning tops, the full skirts of these Spanish dancers leave a whirling trace on the film. A slow shutter – 1/15 – softens the dancers' outlines but sharply records the spectators at the edge of the stage.

The hurtling momentum of machines allows you to use fairly fast shutter speeds and still suggest motion. For the dusk shot of a fairground, the photographer chose a shutter speed of 1/125.

Anticipating the moment

Nearly all photography needs an alert sense of timing. This means being able to respond instinctively to the image in the viewfinder, so that you release the shutter at the best possible moment. But, to be sure of taking consistently good pictures, you also need anticipation and planning, especially with action photographs.

The faster the subject is moving, the more preparation becomes essential. The explosiveness of most sports, for example, means that you need to work out your shots before the action starts. At a horse race, you might decide that the instant of maximum visual energy will occur just as the horses burst from the starting gates. To capture it you will need to line up the viewfinder on the gate, carefully select the framing, and preset both focus and exposure. Then, when the moment you saw in your mind's eye arrives, you will not be left fumbling with the controls. Some action shots – such as the picture of a hurdler below – are not possible without planning, no matter how fast the photographer's reactions are.

Anticipating the best moment for a shot can be equally important with more static subjects, such as landscapes or buildings, because of the way the changing light affects their appearance and mood. If possible, observe your subject at different times of day, or try to imagine the scene with the sun in different positions in the sky. The city panorama opposite, for example, is far more impressive thrown into relief by a low sun than it would have looked an hour earlier.

From a tall building, the city of Caracas spreads below as a forest of buildings. Given access to this high vantage point, the photographer had realized that the scene would be at its best as the sun went down and timed his visit for the evening. He then waited until the moment the sun reached the horizon to take full advantage of the moody effect of the light.

Planning, anticipation, and split-second timing were needed to catch the hurdler at this dramatic moment. Before the race began, the photographer selected one particular runner and set the focus on one of the hurdles he would cross. With the exposure controls also preset, the shutter was fired at the moment the approaching athlete came into sharp focus above the hurdle.

cantabrian

Closing in

Taking photographs at close range reveals a world that usually goes unnoticed – a world full of delicate patterns, beautiful colours and textures. Apart from the wealth of natural subjects – rocks, shells, fruits, flowers or insects – many man-made objects that would look dull when shot at a normal scale become startling when isolated in close-up. With a normal 50mm lens you can focus as close as about 18 inches, and this is generally sufficient for most photographic situations. But if you are shooting a very small subject, such as a flower or an insect, even with the lens at its minimum focusing distance you will be unable to fill the frame with it and show every small detail. For this you need a special type of lens called a macro lens or some form of close-up attachment (as shown below) that allows you to focus closer to your subject and thus obtain a larger and more detailed image of it on the film.

Most close-up equipment works on the same basic principle – it moves the lens farther away from the film, to bring very close objects into focus and magnify the image. In the process, the brightness of the image decreases, as light has to travel farther to reach the film. And this, in turn, affects exposure. A camera with through-the-lens metering will indicate the adjusted exposure necessary. Otherwise, and if the close-up attachment you are using does not couple the lens diaphragm to the camera body, you must make extra exposure calculations.

Precise focusing is crucial when you are working close up, as depth of field is extremely shallow – in some cases no more than a few millimetres. Often you can take advantage of this limitation to empha-size the centre of interest. But to obtain a sharp image of the whole of a small subject, you will have to choose a viewpoint that requires least depth of field, and select the smallest aperture possible. This means either mounting the camera on a tripod for a long exposure or using flash to supply more light. When you take pictures of flowers or insects in their natural habitat, flash is generally the best solution, since it will freeze movement, as well as bring out bright colours. If lighting conditions permit, try to use fairly slow film for close-up work, because the graininess of fast film may obscure fine detail you want to record.

Close-up equipment

A macro lens can be used for both ordinary shots and close-ups, since it can focus on subjects from infinity down to a few inches away. It performs best at very close range.

Supplementary lenses that screw onto the front of the lens are available in varying strengths. They do not cut down the light, and several can be added to obtain greater magnification.

Extension tubes can be fitted to move the lens farther from the focal plane and permit closer focusing. They cost little, come in varying lengths, and can be added to record images of small objects at life size.

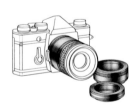

Bellows units fitted between camera body and lens permit continuous adjustments of focus, unlike the rigid tubes. They cost more but also magnify more, because they stretch the lens farther out from the camera body.

Old boots and gloves may seem an unlikely subject, but close framing of such everyday objects forces the viewer to see them anew, often with pleasure.

The crisp outline of a butterfly stands out clearly against the muted background. When you are working close up, you can more easily keep subjects in sharp focus if they are spread out along a fairly flat plane.

The intricate patterns of the natural world may need the extra magnification of close-up equipment to do them justice. Notice the way that the minimal depth of field results in only the near side of the horse chestnuts being in focus, with the far side blurred.

Using simple filters

Sometimes you can improve your pictures by using filters to change, control or partly block light entering the lens. Although this may sound complicated, filters are just thin sheets of glass, gelatin or plastic that either screw onto the lens front or slip into special holders in the same position.

The filters that are used most often are those that clean up the light from the subject. Skylight or ultraviolet (UV) filters absorb ultraviolet radiation, which can make distant objects appear hazy, particularly when conditions are very bright. Use them in conjunction with a lens hood, which will help to exclude the stray light that sometimes reaches the lens, causing flare and softening the image.

In some circumstances, a polarizing filter can produce even more useful effects. This filter can cut down glare from the sky, from water, from glass or other reflective surfaces. Light travelling from these surfaces often becomes polarized, which means that it vibrates mainly in one plane instead of at all angles perpendicular to its line of direction. By blocking the polarized plane, the filter gives a sharper image, and will attractively darken a blue sky.

Another important group of filters absorbs specific colours. A pale yellow filter, for example, passes red and green light but blocks blue. Because this leaves the blue areas underexposed, yellow filters can be used in black-and-white photography to darken the sky and make clouds stand out boldly. With colour film, however, every part of the scene will be subtly tinted toward the colour of the filter you use. The yellowish series of filters widely known by the Kodak serial number 81, for example, can be used to impart a general warm tint.

You can also buy a great variety of special effects filters. Use them with care as they can all too easily create effects that are garish rather than attractive.

No filter

With polarizing filter

Polarizing filter
This type of filter helps to cut unwanted glare. Rotate the filter's ring until the image in the viewfinder darkens.

The startling difference between the two pictures of prehistoric rock engravings in Utah (above) shows the ability of a polarizing filter to reveal detail that would otherwise be hidden by glare. Polarizing filters also have the effect of darkening blue skies, as in the atmospheric picture of trees (below), and can often enliven landscapes.

UV filter and lens hood
An ultraviolet filter attached permanently to the lens will improve your outdoor pictures and protect the delicate front of the lens. Lens hoods should frame the picture area closely. Square types such as the one at left with modified corners do this most effectively. They are particularly suited to wide-angle lenses, because circular hoods sometimes cut off the corners of the image at wide apertures.

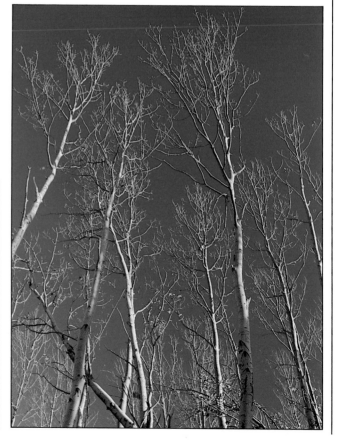

A soft, misty look can be
introduced with a diffusion
filter as in the romantic
image of the flowers in the
picture at far right.

The seascape below has
been improved by a graduated
filter that darkens part of the
image. Without the filter, the
sky would have appeared as
an empty area of white. The
filter contributes the colour.

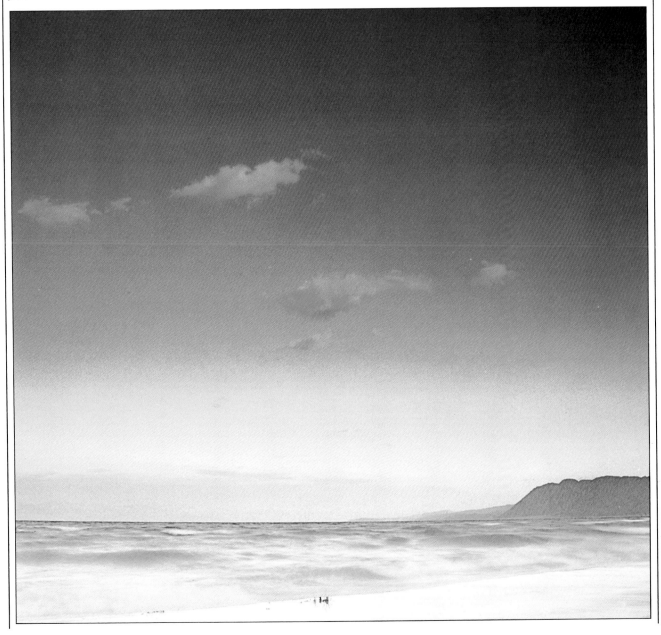

Recognizing patterns and outlines

The world is rich in bold outlines and rhythmic patterns that have strong visual attractions when they are isolated and emphasized in photographs. Finding them is largely a matter of forgetting for the moment that you are looking at things in a literal way – as trees, buildings or individual people – and trying to see the underlying design of the picture in your viewfinder. Learning to see patterns and outlines will help you to produce less haphazard photographs even when these more abstract visual qualities are not the main point of the picture.

Patterns are everywhere, and the camera's ability to close in on the most significant parts of a scene enables you to accentuate such patterns by framing the shot to exclude more random elements. Similarly, you can emphasize patterns by viewpoint and camera angle, as in the picture of the windmill on the opposite page, for which the photographer took

up a position that stresses the lines of planking.

Outlines are somewhat harder to recognize, because in the real world we do not usually see things in terms of flat areas of shape or colour, except when they are silhouetted. But photography has a particular capacity to transcribe the three-dimensional world in terms of basic outlines – especially when light is coming from behind the subject. You can produce simple, forceful pictures by deliberately placing the subject between you and the light and choosing an exposure for the background rather than for the immediate subject. For best results, there should be a difference of at least three stops on your meter scale between subject and background. Alternatively, shapes can be emphasized by contrasting a light subject against a dark background, or a shape of one colour against a plain background of another hue.

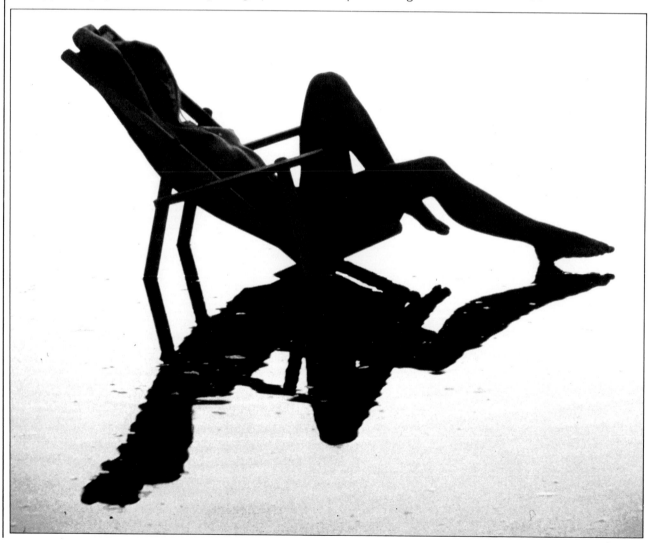

A windmill becomes a graphic pattern of rushing lines, which almost conceal the true identity of the subject. The photographer took full advantage of the bright sunlight to emphasize shadows, forming solid black lines between the boards and throwing the back of the mill into darkness.

The random patterns of nature can easily be vividly emphasized. For this photo of a barnacle-encrusted rock, the photographer moved in close in order to exclude the surroundings, and framed an attractive pattern that is reminiscent of a modern abstract painting.

Backlit in a deck chair, the nude girl (left) appears as a bold, near-silhouetted shape, reflected intriguingly in the shallow water. The photographer had set the exposure for the lighter background so that the girl herself would appear as a dark, outlined shape with little visible detail.

Exploiting colour

Colour in photography is more than just a property of the film you put into a camera. It can be the whole subject of the picture, the one element that makes a scene sing with energy. But like any other subject, colour has to be searched out and positioned carefully within the frame. For example, the photographer of the boat in the picture on the right placed himself so that the sun would glow through the brilliant spinnaker as it collapsed.

Colours do not have to be bright or spread across the picture area to be effective. In nature, it is more often a harmony of muted hues that gives us pleasure, or the single, vibrant accent of a flower or a tree in autumn flame. Yet a good way to start using colour as a subject in itself is to try to spot areas of plain, strong colour in man-made things — signs, shirts, dresses, boldly painted doors, fences, or walls (below) — and position yourself so that they fill the frame and make the picture on their own.

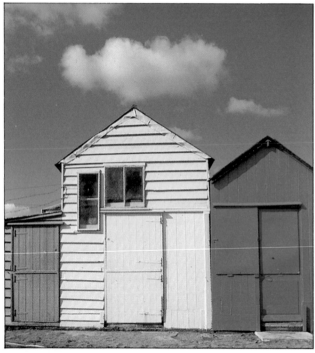

A row of beach huts makes a vivid, simple image that has all the more impact because yellow and blue are strongly contrasting colours. Together with the vivid blue sky, they turn the picture into an almost flat pattern of pure colour. The photographer had only to see the possibilities and frame the scene tightly.

A backlit spinnaker blazes orange, red and yellow as light shines through the translucent fabric. During an offshore race in the Bahamas, the photographer took up position opposite a buoy so he could catch the visual drama of the instant when the sail was hauled in, bringing colour swirling around the boat.

98

Glossary

The following glossary provides brief definitions of the technical terms used in this volume. It is intended primarily for quick reference, and most of the terms are explained adequately and discussed in context, when they occur for the first time in the main text. You can find the relevant passages by referring to the index at the end of the book.

Accessory shoe
A fitting on top of a camera that incorporates a live contact for firing a flashgun. It makes contact between the flashgun and the shutter circuit to provide flash synchronization. The term "hot shoe" is sometimes used as an alternative to accessory shoe.

Aerial perspective
An effect of depth in a picture created by haze in the atmosphere, causing distant parts of a landscape to appear blue and softened.

Angle of view
The angle over which a lens accepts light or "sees". The longer the focal length of a lens, the narrower its angle of view will be.

Aperture
The opening in a lens that admits light. Except in very simple cameras, the aperture can be varied in size by a diaphragm, which regulates the amount of light passing through the lens on to the film.

ASA see FILM SPEED

Automatic exposure
A system that automatically sets correct exposure by linking a camera's exposure meter with the shutter or aperture or both. There are three main types: aperture priority (the most popular), when the photographer sets the aperture and the camera selects the appropriate speed; shutter priority, when the photographer chooses the speed and the camera sets the correct aperture; and programmed, when the camera sets both aperture and shutter speed. Aperture priority is advantageous when you want to control depth of field; shutter priority comes into its own particularly in action photography; and programmed exposure can be useful when the photographer has to react quickly.

Automatic focusing
A camera system that automatically brings the lens into sharp focus on the subject. The most common method of automatic focusing works on the same principle as the rangefinder, using two mirrors within the camera to compare two views of the same scene. Other systems use ultrasonic waves or a beam of infra-red light. The sound or light waves bounce back from the subject, enabling a receiver on the camera to calculate how far away the subject is and adjust the lens accordingly. This happens so quickly that to the photographer it seems instantaneous. Automatic focusing is used mainly on compact cameras, but autofocus lenses are available for some SLRs.

Bounce flash
A technique of softening the light from a flash source by directing it onto a ceiling, wall, board or similar reflective surface before it reaches the subject.

Bracketing
A way to ensure accurate exposure by taking several pictures of the same subject at slightly different exposure settings above and below (that is, bracketing) the presumed correct setting.

Cable release
A thin cable encased in a flexible rubber or metal tube, used to release the shutter when the camera is not being handheld. Use of the cable release helps to avoid vibration when the camera is mounted on a tripod or set on a steadying surface for a long exposure.

Cartridge
A plastic container of film that drops into the camera without any need for film threading. Cartridges are used mainly for 110 format cameras.

Cassette
A metal or plastic container of 35mm film with a tongue to be threaded to a rotating spool within the camera. After exposure the film is wound back into the cassette before the camera back is opened.

Cast
An overall tinge of a particular colour in a print or slide.

Close-up lens (supplementary lens)
A simple one-element lens placed over a normal lens, in the same way as a screw-on filter, allowing the camera to be focused closer to a subject.

Colour negative (print) film
Film processed as a negative image from which positive prints can be made.

Colour transparency (slide) film
Film giving direct colour positives in the form of transparencies. It is also known as reversal film.

Compact camera
A simple 35mm camera that has a non-interchangeable lens and is intended primarily for taking snapshots.

Cropping
Trimming an image along one or more of its edges to eliminate unnecessary parts, or framing a scene to leave out parts of the subject.

Depth of field
The zone of acceptable sharpness in a picture, extending in front of and behind the plane of the subject that is most precisely focused by the lens. You can control or exploit depth of field by varying three factors: the size of the aperture; the distance of the camera from the subject; and the focal length of the lens. If you decrease the size of the aperture, the depth of field increases; if you focus on a distant subject, depth of field will be greater than if you focus on a near subject; and if you fit a wide-angle lens to your camera, it will give you greater depth of field than a normal lens viewing the same scene. Many SLRs have a depth of field preview control – a button that closes the lens diaphragm to the aperture selected for an exposure so that the depth of field in the image can be checked on the viewing screen first.

Diaphragm
The part of the camera that governs the size of the aperture. The most common type is the iris diaphragm – a system of curved, overlapping metal blades that form a roughly circular opening similar to the iris of the human eye, and variable in size.

Diffused light
Light that has lost some of its intensity by being reflected or by passing through a translucent material. The translucent material can be natural (for

example clouds) or man-made (tracing paper). Diffusion softens light by scattering its rays, eliminating glare and harsh shadows, and thus can be of great value in photography, especially in portraiture.

DIN see FILM SPEED

Disc camera

A pocket-sized camera that exposes a small circular disc of film contained in a light-tight cassette. Designed primarily for snapshots, the main advantage of the disc camera over types using conventional film is that it enables processing to be highly automated.

Element see LENS

Emulsion

The light-sensitive layer of a film. In black-and-white films the emulsion usually consists of very fine grains of silver halide suspended in gelatin, which blacken when exposed to light. The emulsion of colour films contains molecules of dye in addition to the silver halide particles.

Exposure

The total amount of light allowed to pass through a lens to the film, as controlled by both aperture size and shutter speed. The exposure selected must be tailored to the film's sensitivity to light, indicated by the film speed rating. Hence overexposure means that too much light has created a slide or print that is too pale. Conversely, underexposure means that too little light has resulted in a dark image. Many cameras have built-in exposure meters that measure the intensity of light so as to determine the shutter and aperture settings that are most likely to produce an accurate exposure.

Fast lens

A lens of wide maximum aperture, relative to its focal length, allowing maximum light into the camera in minimum time. The speed of a lens – its relative ability to take in light – is an important measure of its optical efficiency: fast lenses are harder to design and manufacture than slow lenses, and consequently cost more.

Fill-in light

Additional lighting used to supplement the principal light source and brighten shadows. Fill-in light may be supplied by redirecting light with a card reflector or by using a flash unit, for example.

Film speed

A film's sensitivity to light, rated numerically so that it can be matched to the camera's exposure controls. The two most commonly used scales, ASA (American Standards Association) and DIN (Deutsche Industrie Norm), are now superseded by the system known as ISO (International Standards Organization). ASA 100 (21° DIN) is expressed as ISO 100/21° or simply ISO 100.

Filter

A thin sheet of glass, plastic or gelatin placed in front of the camera's lens to control or change the appearance of the picture. Some filters affect colour or tone; others can, for example, cut out unwanted reflections, help to reduce haze or be used to create a variety of special effects.

Flash

A very brief but intense burst of artificial light, used in photography as a supplement or alternative to any existing light in a scene. Flash sources take various forms. Some small cameras have built-in flash, but for SLRs the most popular flash units slot into the top of the camera.

F-number

The number resulting when the focal length of a lens is divided by the diameter of the aperture. A sequence of f-numbers, marked on the lens ring or dial that controls the size of the lens diaphragm, calibrates the aperture in regular steps (known as stops) between the minimum and maximum openings of the lens. The f-numbers generally follow a standard sequence, in such a way that the interval between one full stop and the next represents a halving or doubling in the image brightness. The f-numbers become progressively higher as the aperture is reduced to allow in less light.

Focal length

The distance, usually given in millimetres, between the optical centre of a lens and the point at which rays of light from objects at infinity are brought to focus. In general, the greater the focal length of a lens, the smaller and more magnified the part of the scene it includes in the picture frame. A normal lens for a 35mm camera typically has a focal length of 50mm, a wide-angle lens for the same camera one of 28mm, and a telephoto lens one of 135mm.

Focal plane

The plane on which the image of a subject is brought to focus behind a lens. To produce a sharp picture, the lens must be focused so that this place coincides with the plane on which the film sits in the camera.

Focusing

Adjusting the distance between the lens and the film to form a sharp image of the subject on the film. The nearer the object you wish to focus on, the farther you have to move the lens from the film. On most cameras you focus by moving the lens forward or backward by rotating a focusing control ring.

Format

The size or shape of a negative or print. The term usually refers to a particular film size, for example 35mm format, but in its most general sense can mean simply whether a picture is upright (vertical format) or longitudinal (horizontal format). Cameras are usually categorized by the format of the film they use.

Grain

The granular texture appearing to some degree in all processed photographic materials. In black-and-white photographs the grains are minute particles of black metallic silver that constitute the dark areas of a photograph. In colour photographs the silver is removed chemically, but tiny blotches of dye retain the appearance of grain. The more sensitive – or faster – the film, the coarser the grain will be.

Hot shoe see ACCESSORY SHOE

Incident light reading
A method of measuring the light that falls on a subject as distinct from the light that is reflected from it. To take this kind of reading, the exposure meter is pointed from the subject toward the camera.

ISO see FILM SPEED

Latitude
The ability of a film to record an image satisfactorily if exposure is not exactly correct. Black-and-white and colour print films have more latitude than colour transparency films, and fast films have greater latitude than slow ones.

Lens
An optical device made of glass or other transparent material that forms images by bending and focusing rays of light. A lens made of a single piece of glass cannot produce very sharp or exact images, so camera lenses are made up of a number of glass "elements" that cancel out each other's weaknesses and work together to give a sharp, true image. The size, curvature and positioning of the elements determine the focal length and angle of view of a lens.

Long-focus lens
A lens that includes a narrow view of the subject in the picture frame, making distant objects appear closer and magnified. Most long-focus lenses are of the type known as telephoto lenses. These have an optical construction that results in their being physically shorter than their focal length, and consequently easier to handle than non-telephoto long-focus lenses. In fact almost all long-focus lenses are now telephoto lenses, and the two terms tend to be used interchangeably.

Motordrive
A battery-operated device that attaches to a camera and automatically advances the film and re-tensions the shutter after an exposure has been made. Some motordrives can advance the film at speeds of up to five frames per second, so they can be useful particularly for sports and other action photography.

Normal lens (standard lens)
A lens producing an image that is close to the way the eye sees the world in terms of scale, angle of view and perspective. For most SLRs the normal lens has a focal length of about 50mm.

Panning
A technique of moving the camera to follow the motion of a subject, used to convey the impression of speed or to freeze a moving subject at slower shutter speeds. Often, a relatively slow shutter speed is used to blur the background while panning keeps the moving object sharp.

Rangefinder
A device for measuring distance, used as a means of focusing on many cameras. The rangefinder works by displaying, from slightly different viewpoints, two images that must be superimposed or correctly aligned to give the exact focusing distance. A "coupled range-finder" is one linked to the lens in such a way that when the two images in the viewfinder coincide, you know that the lens is automatically focused to the correct distance.

Reflex camera
A camera employing a mirror in the viewing system to reflect the image onto a viewing screen. The most popular type is the single lens reflex (SLR), which reflects the light from the same lens that is used to take the picture. The twin lens reflex (TLR) has an additional lens for viewing. A single lens reflex camera shows the image in the viewfinder as it will appear on the film, whatever the lens used.

Self-timer
A device found on many cameras that delays the operation of the shutter, usually until about eight to ten seconds after the release is pressed. This allows the photographer to set up the camera and then pose in front of the lens.

Shutter
The camera mechanism that controls the duration of the exposure. There are two main types: between-the-lens shutters are built into the lens barrel close to the diaphragm; focal plane shutters are built into the camera body, slightly in front of the film.

Silver halide
A chemical compound of silver (usually silver bromide) used as the light-sensitive constituent in films. The invisible image produced when the halides are exposed to light is converted to metallic silver when the film is subsequently developed.

SLR see REFLEX CAMERA

Soft focus
Deliberately diffused or blurred definition of an image, often used to create a dreamy, romantic look in portraiture. Soft-focus effects are usually created with special lenses or filters embossed so that the glass surface breaks up the light by means of refraction.

Sprocket
A small projection on the camera spool that winds the film forward or back in the film chamber. The sprockets connect with the perforations ("sprocket holes") along the edges of the film, and move the film through the camera.

Standard lens see NORMAL LENS

Stop see F-NUMBER

Stop down
A colloquial term for reducing the aperture of the lens.

Subject
The person, object or scene recorded in the photograph.

Supplementary lens see CLOSE-UP LENS

Telephoto lens see LONG-FOCUS LENS

Time exposure
An exposure in which the shutter stays open for as long as the photographer keeps the shutter release depressed. Time exposures may be necessary in dim light and are usually made using a cable release and with the camera mounted on a tripod.

TLR see REFLEX CAMERA

Tripod
A three-legged camera support. The legs (usually collapsible) are hinged together at one end to a head to which the camera is attached.

TTL
An abbreviation for "through-the-lens," generally used to refer to exposure metering systems that read the intensity of light that has passed through the camera lens.

Viewfinder
The window, screen or frame on a camera through which the photographer can see the area of a scene that will appear in the picture.

Wide-angle lens
A lens with a short focal length, thus including a wide view of the subject in the frame.

Zoom lens
A lens of variable focal length. For example, in an 80-200mm zoom lens, the focal length can be changed anywhere between the lower limit of 80mm and the upper of 200mm. This affects the scale of the image on which the lens is focused without throwing the image out of focus.

Index

Acknowledgements

Picture Credits
Abbreviations used are: t top; c centre; b bottom; l left; r right.

Michael Freeman, the consultant photographer for this volume, is abbreviated as MF, and Image Bank as IB.

Cover © Mitchell Beazley/MF inset P Pfander/IB

Title Page MF. **6-7** MF. **8-9** Alan Brebner. **10** Luis Huesco. **11** Russell D Arthur. **12** Peter Knapps/IB. **13** Geg Germany. **14** Nadia MacKenzie. **15** Ronald Kaufman. **16-17** F Damm/Zefa. **18** bl Audrey Stirling/Daily Telegraph Colour Library, tl c MF. **18-19** MF. **19** c MF. **20** t David W Hamilton/IB, l R Phillips/IB, br Jean & C Fichter/IB. **21** Larry Dale Gordon/IB. **22** Cecil Jospé. **23** tl Sally & Richard Greenhill, tr Geg Germany/Daily Telegraph Colour Library, b John Sims. **24** tl Sergio Dorantes, bl R Nuettgens/Zefa, r Herb Gustafson. **25** Pablo Ortiz. **26** l Ian McKinnell. **26-27** David Hamilton/IB. **28-29** MF/P Pfander/IB. **34** b Graeme Harris. **35** bl Tony Spalding, br Cecil Jospé. **37** tr Michelle Garrett. **39** J Alex Langley/Aspect Picture Library. **41** tr c John Garrett. **42** br Ian McKinnell. **42-43** l c r MF. **43** bl Stuart Windsor, br Leo Mason. **44-45** All MF. **46** t John Sims, b Jerry Young. **47** John Sims. **48** tr John Topham Picture Library, b Barry Lewis/Network. **49** Carol Sharp. **50** t Linda Burgess. **51** t C Chassagne/IB. **52-53** Mike Abrahams/Network. **55** t Christian Kempf, b John Garrett. **57** tl tc tr Michael Busselle, b Alastair Black. **58** b Michael Busselle. **59** t Dick Scott-Stewart, b John Garrett. **60-61** All MF. **62** MF. **63** t b MF, c Sally & Richard Greenhill. **64** t Vince Streano/Aspect Picture Library. **65** t MF, b Frank Wing/IB. **67** b Neill Menneer. **68-69** MF. **70-71** Harold Sund/IB. **72** MF. **73** t Gregory Slater, b Cindra K Bump. **74-75** all Vautier/de Nanxe. **76** t MF, b Laura Clark. **77** J-C Lozouet/IB. **78** t Pete Turner/IB, b Andrew Lawson. **78-79** Brian Seed/Click/Chicago. **80** W Iooss/IB. **81** l Julian Calder, r MF. **82** r Brian Seed/Click/Chicago. **83** John Hedgecoe. **84** l Simon Yeo, r Thomas W Wienand. **85** Julian Calder. **86** Hans Feurer/IB. **87** John Garrett. **88** bl Jean-Paul Ferrero/Ardea. **88-89** t Leo Mason, b Michael MacIntyre. **89** bl Daniel Forer/IB. **90** Tony Duffy/All-Sport. **90-91** MF. **92** Karri Vinton. **93** t Don Hadden/Ardea Photographics, b Linda Burgess. **94** t MF, b Paul Damien/Click/Chicago. **95** t Geg Germany, b C Thomson/IB. **96** Paolo Curto/IB. **97** l David & Kate Urry/Ardea London, r Michael Busselle.

Additional commissioned photography by John Bellars, Paul Brierley, John Miller

Acknowledgements Inter City Cameras, Keith Johnson Photographic, Leeds Camera Centre, Minolta, Nikon, Pelling & Cross, Rother Cameras.

Artists Kuo Kang Chen. Brian Delf, Roy Flooks, Alun Jones, Richard Lewis, Haywood Martin, Coral Mula, Sandra Pond, Andrew Popkiewicz, Jim Robins, Alan Suttie.

Retouching Roy Flooks, O'Conner/Dowse

Hand colouring Helena Zakrzewska-Rucinska

Kodak, Ektachrome, Kodachrome and Kodacolor are trademarks

Typeset by Hourds Typographica Limited, Stafford, England
Colour separation by Aero Offset, Eastleigh and Gilchrist Bros. Ltd., Leeds, England.

XXXX